Ley Lines

Ley Lines

H. L. HIX
CURATOR

"Under a stagnant sky;
Gloom out of gloom uncoiling into gloom,
The River, jaded and forlorn,
Welters and wanders wearily — wretchedly — on;
Yet in and out among
Of the old skeleton bridge, as in the piers
Of — the dead lake-built city, tall of skulls,

...ation!"
And here are n
the rhythms
or disguise

exclusively of
verse, in broken
type);

WILFRID LAURIER
UNIVERSITY PRESS

Wilfrid Laurier University Press acknowledges the financial support of the Government of Canada through the Canada Book Fund for our publishing activities.

Library and Archives Canada Cataloguing in Publication

Ley lines / H.L. Hix, curator.

Issued in print and electronic formats.
ISBN 978–1–77112–032–6 (pbk.).—ISBN 978–1–77112–034–0 (epub).—
ISBN 978–1–77112–033–3 (pdf)

1. Creation (Literary, artistic, etc.). 2. Creative ability. I. Hix, H. L., curator

BH39.L49 2014 701'.17 C2014–905259–6
 C2014–905260–X

Front-cover image by Sarah Walko: *We explained we breathe through glaciers ...* (acrylic, ink, and collage on paper, 2009, 24" × 36"); photograph by Etienne Frossard. Image courtesy Sarah Walko. Cover design and interior design by Lime Design Inc.

© 2014 Wilfrid Laurier University Press
Waterloo, Ontario, Canada
www.wlupress.wlu.ca

This book is printed on FSC recycled paper and is certified Ecologo. It is made from 100% post-consumer fibre, processed chlorine free, and manufactured using biogas energy.

Printed in Canada

Every reasonable effort has been made to acquire permission for copyright material used in this text, and to acknowledge all such indebtedness accurately. Any errors and omissions called to the publisher's attention will be corrected in future printings.

MIX
Paper from
responsible sources
FSC® C004071

Contents

About This Book

Rationale

⊢→ DEMOCRACY, as an ideal no less than as a lived reality, is discursive. *Whether* we speak with another, *how* we speak with one another, *what* we speak with one another about: these *matter*. They condition civility. They symptomatize the health or illness of the body politic no less than do the ways we *act* toward one another. Indeed, how we speak with one another is inseparable from, and constitutive of, how we act toward one another. In an important sense, the opposite of war is not *peace* but *dialogue*. Which makes poetics a form of statecraft, conversation an element of citizenship.

So pervasive, by contrast, is the language of commerce, the aim of which is not to ascertain truth but to co-opt *your* agency for *my* profit, that we hardly notice its entailment of a compact based on mutual *dis*trust, its transformation of our social contract into an alliance of thieves, the dissimulation by which it *dis*covers the profit of one by *cover*ing the harm to another. Ironically, the state of nature, of civil war of each against every other, that Thomas Hobbes described as the *absence* of civilization, as the condition we must by all means

1

strive to avoid because in it human life is "solitary, poor, nasty, brutish, and short," is precisely the condition embraced by the language of commerce, for which the laissez-faire, wholly unregulated competition, provides the ideal. This book has sought to provoke — to *be* — dialogue on different terms, dialogue in which, as speakers and as listeners alike, we act not as *consumers* but as *makers*, not as *competitors* but as *conversants*. Or, to use our word that comes from the Greek word for making, a dialogue in which we *speak with* one another and *listen to* one another, as *poets*.

That aim explains why the speakers in the conversation this book convenes are writers and artists: not because I accept at face value Shelley's declaration that poets are "unacknowledged legislators," but because I regard the making that writers and artists practice as an example, a type of the making that *any* citizen might practice. Writers and artists, on such a view, do not legislate (they don't tell us what we must do or not do) but they do model (show us what we might do and how we might be). The premise of this book is that Emily Dickinson, say, shows me a better possible citizen/self — Walmart and BP, a worse.

Process

THIS ONE BOOK PROJECT began as two blog projects. In one of those two, called "Show and Tell," I solicited from numerous artists images of two pieces of their work, in the form of digital files, accompanied by an artist statement. I then sent one image to one writer, one image to another, inviting each writer to respond as she or he saw fit. In many cases I received no response at all. (I was surprised at how difficult people found this: how many more artists I solicited than sent me images, and how many more writers agreed to respond than actually did.) The responses I did receive varied widely, from poems to critical reflections to memoiristic recollections. In the other project, called simply "Q&A," I abbreviated the standard interview format into "mini-

interviews" of writers, mostly poets: really just a single question in each case, posed to a poet about a book she or he had recently published.

This book takes those two conversations and creates from them, by selection and arrangement, a third conversation. From both projects I have chosen instances I find especially engaging, and I have "layered" those conversations, first by pairing a "mini-interview" with an artist-writer exchange, and then by grouping *those* pairings into clusters of three that seem to me, continuing the conversation metaphor, to "talk to one another." To those layers I have added another, a short introduction to each cluster, that tries (after the fact) to identify the resonance that creates the cluster. In some, the basis for association of parts with one another is tangible: for instance, Sue Sinclair and Anna Von Mertens have been placed one after the other because both, quite independently of one another, appeal to Walter Benjamin's notion of the "aura." In others, the basis for association is more intuitive: I couldn't account for my associating Kirsten Kaschock with Daniel Dove and Ann McCutchan any more clearly than to say "it just felt right."

<hr style="width:20%" />

Participants

WE ARE BOTH OF US, I the curator and you the reader, compositors of this work, participants in the conversation it seeks to *be* and to *provoke*. In addition to us, the other participants are artists and writers. They include persons I know quite well: Alyson Hagy, for example, is a close friend and colleague, with whom I have team-taught courses in the university in which we both currently are employed, and Adriane Herman is a friend and former colleague, with whom I occasionally team-taught when we were employed together at another college. The participants also include many persons I know less well than I would like, such as Afaa Michael Weaver, with whom I have enjoyed correspondence but whom I have never met in person. And they include

persons who "wouldn't know me from Adam," such as Vera Scekic, whose work I happened upon in reproduction in a periodical years ago, and who I solicited to participate in the "Show and Tell" project because that work had "stayed with me," though she and I have never met. In all cases, though, the participants are persons *by* whose work I *have been*, and *with* whose work I *am*, engaged.

One organizing principle here has been to put together practitioners who did not know one another, or one another's work, beforehand. It has been my hope that this "matchmaking" aspect of the composition would spark further conversation between those linked here. I hope also that there will be *unguided* matchmaking: that readers will be led to find additional work by favorite participants here, as for example by exploring the websites of favorite artists or the books of favorite writers.

Elements and Pattern

ANY COMPOSITION has elements and a pattern. In the familiar composition we call an "interview," the elements are questions and answers, and the pattern simple alternation: interviewer asks a question, interviewee replies, and so on. *This* composition, this book, is built of a few more elements than that, and built into a pattern slightly more complex but no less regular. The elements are the following: question, answer, image, artist statement, response to image. The pattern is to assemble one of each element, presented in that order, into a unit, and then to cluster three such units into a group, introducing each group by a short meditation on the energy and insight of the "conversation" created by the grouping. I don't pretend that this is the *best* arrangement of the elements, but I do present it as a *generative* one.

Its being composed of these elements in this pattern makes this book more *synthetic* than *analytic*. I mean by that distinction only that this book doesn't so much *break down* its subject as *add up to* its subject. We are accustomed to

receiving from books analysis, a breaking-down: a book declares its subject early (even in its title), and then breaks that subject down in ways that enhance readers' understanding of it. (A self-help book breaks down a problem in such a way that the reader may more effectively address that problem in her or his own life; a biography breaks down the life of a public figure in such a way that the reader may understand and identify with that life; and so on.) Such analysis is valid and important, a good and proven way of approaching a subject. It is not the *only* way, though, and this book proceeds differently, by synthesis, discovering its subject by accumulation. It operates after the manner of a poetry collection, the whole of which is achieved by resonance among the parts, and the subject of which may be plural — *subjects* — rather than singular. This book is designed, in other words, less as a *lecture to* than as a *conversation with* its reader, inviting the reader's own concerns to become themselves elements of the work.

The boundaries of this composition are porous. Which is to say that, like any good conversation, it extends beyond its occasion. One porous boundary is with the digital realm. The two projects behind this book still exist on my blog (at www.hlhix.com, click on the red IN QUIRE button), and since this book is a *selection*, the two projects post on the blog many instances not presented here. Implicitly, they invite the reader/viewer to synthesize additional selections/orderings. Another porous boundary is with continuations of this conversation. An exhibition at the University of Wyoming Art Museum is scheduled to coincide with the publication of this book, to enable the two — book and exhibition — to "converse," extending the conversation to include viewers of the exhibition. Yet another porous boundary is with my own ways of entering and continuing this conversation. In response to the artist/writer pairings, I wrote a series of poems that have become the second half of a collection entitled *As Much As, If Not More Than* (Etruscan Press, 2014), and in response to the "mini-interviews" a sequence of poems that have become one section of a collection entitled *I'm Here to Learn to Dream in Your Language* (Etruscan Press, 2015). Of course, I hope that those books will provoke further conversation among readers and critics, just as I hope this one will: I have tried, as per the distinction above, to speak with others and listen to others here as a maker rather than as a consumer, to participate in a poetics of dialogue as a practice of peace.

Mystery

IN *An Ancient Quarrel Continued: The Troubled Marriage of Philosophy and Literature*, the philosopher Louis H. Mackey distinguishes between a problem and a mystery. A problem, he says, "can be solved. The terms in which it is stated define what will count as a solution." A mystery resembles a problem in being "an indeterminate situation that begs to be made determinate," but *differs* from a problem in that "its indeterminacy is such that the description of the mystery does not specify conditions of resolution and closure." A mystery, Mackey says, "cannot be fully described. Faced with a mystery, you can never be sure what will count as a solution, or even that there is one."

This book is structured on the basis of a metaphysical premise, namely, that mystery, not problem, is ultimate. At least since Descartes (maybe since Aristotle, maybe since Lucy), the prevailing view has been that a mystery, pursued long enough and in the right way, resolves itself into a problem. There is always a solution, and (in principle if not in practice) it can be found. This book acts on the minority view: that a problem, pursued long enough and wisely, reveals itself as a mystery.

One problem/mystery pairing has been alluded to above: a political problem, pursued aptly, reveals itself as, and in, the mystery of dialogue. Here is a way to gesture toward that mystery. In *The Waste Land*, one of the voices in which T.S. Eliot "do the police" asks "Who is the third who walks always beside you?" That voice is *aware* of a presence it can't quite *identify*: "When I count, there are only you and I together," the voice says, "But when I look ahead up the white road / There is always another one walking beside you." Similarly, the Gospel of Matthew portrays Jesus as having promised that "where two or three are gathered in my name, there am I in the midst of them." Robert Bly speaks of love as a "third body": "A man and a woman sit near each other; / as they breathe, they feed someone we do not know, / someone we know of, whom we have never seen." Philosophers and theologians appeal to Plato's Greek term *triton ti*, or Tertullian's Latin term *tertium quid*, to refer to that

third thing implied by the two in any binary logic. More recently, Jacques Derrida, exploring the particular binary logic of signification, calls the third thing the *supplement*. "The movement of signification," Derrida avers, "adds something, which results in the fact that there is always more." In dialogue, too, there is always something more. This book attempts to enact, to participate in, the mystery that *when you and I are together in the way of dialogue, we are accompanied by a third, a spiritual presence other and greater than ourselves.* It *is* a *mystery*: its indeterminacy cannot be minimized, nor can resolution and closure be imposed on it. But its being a mystery rather than a problem does not reduce its urgency or its import.

Ways of Dialogue

LITERARY AND VISUAL ART have been together in the way of dialogue on many occasions before this book, of course, often and variously. This book tries to extend that dialogue in manifold ways. That the meeting of visual with verbal might occur within a person or between persons, and that it might take place as the *con*vergence of visual and verbal or as their *di*vergence, creates an array of possible forms of dialogue, each of which this book seeks to enact.

Instances in which visual and verbal converge in one work, created by one person, one might name "merger." William Blake's major works, for example, all integrate images and poetry. The graphic novel offers many contemporary examples of convergence of this sort, such as the work of Marjane Satrapi. When one person produces both visual and verbal work, but the works remain distinct from one another, one might name the result "parallelism." So Michelangelo made notable artworks, but he also wrote a fair number of poems, including some that employ his now-familiar neoplatonic subtractive theory of sculpture, according to which the sculptor reveals the already-existing sculptural figure, by removing from the block all the stone that is not the

figure. A more recent example of parallelism would be Agnes Martin, best known for her meditative minimalist paintings, but also the author of the lyrical, aphoristic meditations gathered into a book called simply *Writings*.

One might name it "response" when two works, rather than one, mediate the encounter between visual and verbal, and when the two works are by two different people, rather than both by the same person. Ekphrastic poetry — poems about works of art — would be one genre in this category, exemplified by any number of poems by Robert Browning: his "Fra Lippo Lippi," for instance, ruminates on a painting by fifteenth-century Italian painter Filippo Lippi. Finally, one might name it "synthesis" when *one* work by *two* people hosts the dialogue, as in documentary work such as *Let Us Now Praise Famous Men*, the book by photographer Walker Evans and writer James Agee, in which Walker's images find confirmation in Agee's text.

I don't mean to be fussy about these categories: it's easy enough to find "category-busters." (As one example, the children's book, that most familiar and accessible instance of the combination of visual and verbal, does not confine itself to one category. *Where the Wild Things Are*, for example, was written and illustrated by one person, Maurice Sendak; in *Charlotte's Web*, in contrast, the visual was contributed by one person, Garth Williams, the verbal by another, E.B. White.) All I mean to note is that there are various ways in which dialogue between visual and verbal might occur, and that, though this book does not try to be all things to all people, it *does* try to engage in dialogue in all the ways just mentioned.

Ley Lines can be viewed as — it consists of — numerous works. It has *parts*. When the book is viewed in this way, the role of any one of the artists, contributing an image and accompanying text, could be described as parallelism, and the role of any one writer/artist pair could be described as response. So, for example, Thomas Lyon Mills' *Caroga* and his meditative artist statement exemplify parallelism, and Evie Shockley's poem works with *Caroga* in the mode of response. But the book can with equal validity be viewed as a single work. It is a *whole*. When the book is viewed in this way, my curatorial role in selecting and organizing the various elements could be described as merger,

and your readerly role of actively engaging the various contributions of others could be described as synthesis.

About dialogue not only in this book but also more broadly, *the various types of dialogue offer ideals to one another.* They are as much a set of correspondences as they are a set of contrasts. For instance, the feature that distinguishes merger from synthesis, namely, that the work is executed by one person rather than two, gives synthesis one of its ideals. One condition for and measure of the success of a synthesis, one ideal toward which it strives, is *unity*: a synthesis succeeds when it functions as if it were a merger. One measure of success, in other words, for the work of two people is how readily it might be mistaken for the work of one person. An analogous reciprocity occurs in the pairing of any two of the types of dialogue. So, just as the actuality of merger gives an ideal to synthesis, so the actuality of synthesis gives an ideal to merger. A merger made by *one* person is most successful when it looks *as if* it were a synthesis made by *two*. That is, each aspect of the work (the image and the text) should be realized as fully and expertly as if it had been made by a specialist devoted exclusively to that medium, not by an amateur, a dabbler, a jack-of-all-trades. Here, to cite only two examples, Laura Mullen's response to Adriane Herman's work, though composed by only one person, a writer, looks as if it could have been composed by two, an artist and a writer, together. Or, conversely, the combination of work by Sreshta Rit Premnath and Debra Di Blasi looks as if it could have been the work of one person.

Here I invoke again the mystery. That what *two* people make works best when it functions as if it had been made by *one*, and what *one* person makes works best when it functions as if it had been made by *two*, offers to our peripheral vision the presence of the third who walks always beside us. I say so not because saying so explains, or because the so said is explained by, this undecidability between the singular and the plural, but because, well, *there it is*.

Without trying to list *all* the combinations by which one form of dialogue lends an ideal to another, let me sketch just two more. Parallelism suggests the ideal of *integrity*. In parallelism, the parallel works may be related to one another in some way, but each is able to stand on its own. Michelangelo's visual

works and his poems may relate to one another, but the Sistine Chapel ceiling would — *does* — work just fine without the poems. This reality of parallelism offers an ideal to response, namely, that the ekphrastic poem (for example), however closely related to the artwork it responds to, has such integrity that in principle it could stand on its own. Or again, response offers parallelism the ideal of *infinity*. For St Augustine, eternity is not merely limitless duration, existing in each moment as that moment passes, but existing wholly in *each* moment at *all* moments. Similarly, Augustine describes omnipresence as not merely limitless extension, the presence of a part of God at every part of the world, but the presence of *all* of God in *each* part of the world. By loose analogy, an ekphrastic poem does not only *extend* the life of a painting or photo, adding another moment and another place to those it touches, but demonstrates the work's eternity. In eternity, Augustine says, "nothing passes by; everything is present," all at once. For Augustine, finite creatures are confined to time, which, alas, does not exist. The past, because it has already gone, no longer exists; the future, because it has not arrived, does not yet exist; and the present, because it has no duration, does not now exist. Ekphrasis, though, is (in this one respect) created in God's image: it marks the overcoming of time, the fullness of all presence in any present.

Such reciprocity of ideals underlies the rationale for this book, offered above. That the reciprocity of ideals across ways of dialogue is not limited to aesthetic dialogue, but extends to all forms of civic dialogue, makes the particular clarity with which writer/artist dialogue manifests the reciprocity of ideals *exemplary*. In dialogue between artists and writers, we witness, and enter a practice of, *exchange* rather than *imposition of* ideals. Into one such dialogue you are now invited, as witness and as participant.

Capacious Enlivened Sense, Complex Daily Ardor

↦ WE *experience* the world in ways that shape, and can correct, how we *understand* it. We *understand* the world in ways that shape, and can correct, how we *experience* it. I regarded my lover as honorable and trustworthy until he betrayed me, until in other words my experience revised my understanding. I experienced older white men as especially authoritative persons until I was shown that such "authority" is socially constructed, until in other words my understanding revised my experience.

Nothing is more common than the attempt to release that tension. Fundamentalisms and dogmatisms of all sorts deny the tension by attributing to a certain understanding immunity from correction by experience. Similarly, hedonisms deny the tension by attributing to a certain kind of experience immunity from correction by understanding. In either case, I am made *intemperate* by refusing to allow one capacity to *temper* the other.

But what if one sought not to release but to acknowledge the tension? What if one sought — to put the matter in terms of the paradox — to understand and experience the tension? Then one might, as Paisley Rekdal does, recognize the "gap between what we appear to be and what we are." One might seek, with Vera Scekic, to "balance chance occurrences with intent." One might embrace the ambiguity of Michelle Boisseau's imperative to "Leave the planet / on the table."

Each writer and each artist in this section, in her or his own way, asks after — seeks to recognize rather than to repress — the tension between experience and understanding, their inseparability and mutual interdependence. Each in some way addresses the fact of betweenness, the ideal of balance, the project of representation. Each asks after what life in private and life in community might be if we sought neither to subdue experience by understanding nor to subdue understanding by experience, but instead to embrace their dynamic, reciprocal, mutually constitutive interrelationship.

Between

HLH: Two things I notice about these poems [in *Animal Eye*, by Paisley Rekdal] seem related to one another. One is that they make important distinctions, such as respecting a thing for itself and respecting it for our imagination of it (p. 3) and the head versus the heart (p. 17). Another is that *betweenness* seems regularly present. Again, just a couple of examples out of several: between the real and the imagined (p. 31), and "the brief air between us" (p. 82). *Are* such contrasts and "betweennesses" important to the poems, and are they related to one another?

Paisley Rekdal: If I had to point to one theme that I think I return to, in one form or another, it's our understanding of what comprises intimacy, whether it's between people or between people and the natural world. I think our general imagination of intimacy is fairly limited: we tend to think of it as meaning the sexual or emotional connection between people in a defined relationship. The result of this is that we also tend to think of our attempts to become intimate with others in limited, physical ways, not also in harder-to-define ways, such as artistic, philosophical, or even legal representation. I think the particular problems of representation — of the self, of the "other" — really haunts most of my recent work. In particular, I'm interested in the ways in which we all, each represented in the world often become the basis for how others around us become familiar or intimate with us; there's always a gap between what we appear to be and what we are, a gap that — as a biracial woman — I think has been literalized for me in my life due to my shape-shifting appearance. Depending on who sees me, for instance, I am either Asian or white, something instantly "nameable" (thus made familiar) or further and further exoticized. I don't think this is only or even primarily about race, however, but about the ways in which all humans have to choose to represent their identities, and their ideas, in art and in language. This, to me, is the essential "betweenness" in which we all live: between a "real" self and a socially imagined self. This is why issues of art and artistic production are everywhere in the book. Also, obviously, images of animals, because I think

that the ways in which we imagine and respond to animals really gets at the heart of our problems of representation. I have three dogs, and I'm constantly amazed by how they have been bred to essentially fit into our human world, often with "humanlike" attributes without ever being human. Reading the work of philosophers like Peter Singer, I'm struck again and again by how difficult it is for us to imagine how we might treat animals in a moral or "humane" way without having to make them human. Essentially, are we willing to give rights to creatures not based on our successful anthropomorphizing of them, but based on the fact that they are their own beings? And how do we make that kind of argument WITHOUT, at some level, anthropomorphizing them, making them more and more like us in our imagery? But if we see ourselves in animals (or try to see ourselves in animals), we also see animals in ourselves, which often gives rise to some of our worst and most racist language and imagery, something else I explore in one of the poems in this collection. But the "betweenness" we experience living with and caring for animals is, I think, an intensely captured microcosm of the "betweenness" we experience living with each other, and I think it was one of the only analogies I could use to help me begin to explore the costs and consequences of our representations of ourselves.

Anne Lindberg, *motion drawing 03*

Anne Lindberg: Neurologists have determined that the *old brain* holds the seat of our most primal understandings of the world. Goodwill, security, fear, anxiety, self-protection, gravity, sexuality, and compulsive behaviors generate from this lower cerebral core.

My sculpture and drawings inhabit a nonverbal place resonant with such primal human conditions. Systemic and nonrepresentational, these works are subtle, rhythmic, abstract, and immersive. I find beauty and disturbance through shifts in tool, layering, and material to create passages of tone, density, speed, path, and frequency within a system. In recent room-sized installations, I discovered an optical and spatial phenomenon that excites me as the work spans the outer reaches of our peripheral vision. The work references physiological systems — such as heartbeat, respiration, neural paths, equilibrium — and psychological states.

I've come to understand my work as a kind of self-portraiture. Within the quiet reserve and formal abstraction is a strong impulse to speak from a deep place within myself about that is private, vulnerable, fragile, and perceptive to the human condition. My work is a mirror of how I experience the world, and as I negotiate physicality, optics, and ideas through drawing languages, my voice withholds, blurs, teases, and veils.

I frequently return to subtle distinctions between drawing as noun *and* verb as a long-held focus in my studio practice. This blurred distinction drives my fascination with an expanded definition of drawing languages and the resurgence of drawing in contemporary art. My collective body of work is an iteration of this language.

Renée Ashley

"On 'Motion Drawing'"

How fast the blood marks us and the ghosts

tucked in Look: your breath breathing your

past your heart beating like a beating You

know this much as well: you are in between

the lines that have no breadth — you can

see you there you're moving — trace of

what we cannot weigh A poet says *A boat*

is called a vessel and the body rides a boat

but we are neither string nor line and we

are listing We cannot see beyond what we

can see We are stone and we are burl We're

salt We're cumbersome of word and word

and word Do you see But image But

concept of line and shake the air We're in

there

Balance

HLH: The formulation "I suppose I do believe in nothing" is repeated several times in your book [*The Firestorm*] (e.g., as part of the first line of three poems in a row on pp. 26–8). The word "do" stops me, and makes me think about the formulation, asking myself whether this is an affirmation or a negation. Consequently, I want to ask you, about the whole book: Are these poems affirming or negating? (Obviously, this is a false dilemma, so feel free to reject the very form in which the question is asked.)

Zach Savich: False, perhaps, but fair to ask. I ask it of many books: what world do they posit? what do they leave out? Do they do what I, lover of TV and walks and coffee, believe only books can do, and expand from that? And I ask it, foolishly, of my life, while knowing that, you know, the tomato sauce may negate the recipe but affirm the wine: the coin has two sides one spins among, so Washington appears to eat the eagle eating him … I hope my poems posit knowledge that is similarly spun, aglint, in motion, not of balance but of exchange; not of a position but of positioning. As, in one's emotional life, contradictions do not necessarily conflict but gesture toward a self that's odd, but not at odds. The self less a character than a setting. Today I felt at home in the afterlife. Today I felt suspiciously alive! Me: the setting where such weather blew; I hope my poems also are …

More concretely, I hope the poems in *The Firestorm* affirm in the manner that vividly observed particulars, through being, appear to: less by saying *yes* than through an insistent, inexhaustible *here is*. A nod that points, rather than assents. Particularly: since the easiest forms of affirmation can feel insufficient ("I saw the geese and knew nature loved me"), and yet the things of the world can still call one to love, or what may be love today.

Is that more concrete? Maybe this will be: I wrote these poems in some years I believed all ideas are only so many words, shrapnel of mood, tires desire is the air and lugnuts of. I knew things, sure, but all things being equal, they were all equally things. I believed I *had* no ideas, no thoughts, only senses

that compose: wind on my face, so I have a face. Thus, poetry, through the senses, composes us, but one must be actively, raptly embodied yet void for such sensations to actually strike, or tune, the mind's kite's fabric so brightly who can tell what's kite, what's string, what's wind. As one of the poems says, I thought there were no actual narratives, economics, or theology, only the geologic triad: heat, pressure, time. Which of those do I wish for today?

So, I hope the poems affirm such capacious enlivened sense, complex daily ardor, clarity as in *distinct* not *comprehensible and a lie.* The mouth speaks warm against my throat. I lean toward its heat; that's the better part of language. The poems preserve, the poems incite. One is in a country we cannot map except by moving through, large enough to speak our minds in. (Hilary Plum and I discussed some related ideas of "not knowing" and sense in our review of Filip Marinovich's second book here: http://therumpus.net/2011/07/whisk -in-the-mouth/#more-84000.)

I should confess: I was driven to such thoughts, grumpily!, in part in over-reaction to what felt/can feel like a current self-satisfied and knowing period poetic style, which strip mines narrow voicey veins of shallow behavioral may-hem (akin to undergraduates' school-sanctioned tailgating, while the forces of righteousness, me and my friends, tailgate nowhere near a game, let's say …), of nonchalant positings, nonchalant metamorphoses, to taxidermy the hardier world of saying/sight into predictably flat declarational orthodox "imagin-ings" that transmit a pose, but leave out most of what one loves in language or the world. Cool kid stuff I'll strawman vaguely here, partly because — if I'm talking about any actual poems, I'm talking about the work of some of my best friends, who will laughingly hold out a net here as I fall, some of my favorite work, lumping it, unreasonably, but the poems in my book did come from try-ing to affirm/negate through such churning, mad at what felt like rote modes of innovation, rote modes of wildness, as I've been before at rote modes of plodding verse. I mean: even if I was an overwound weathervane toward these perceived trends, I wanted my poems to affirm, to be accountable to, how actually vivid, rich, effulgent, difficult, brief, fragile, full true sense is. More than the t-shirt slogan flash of, say, "the geese are trampolines in my brain's trampoline," which feels so similar to the similarly stoned and world-shy

affirmations of (strawman) epiphanic free verse: "The geese are sad calendars of my life." (Might as well thrash out at dull formalism, too: "The geese fly off into the flightless night!") That is, I can delight in such postures (and jealously wish I could write in them), even if there's so much they can't convey, that any good walk can, but I've also honestly felt geese stir winds that listen, graze me. The world, all its negations, have felt live in those unsimple whooshes, with nothing to do with ideas, poetry, its "communities," my aestheticized thrashings: I hope my poems, if they shift in flight, at least sometimes whoosh a bit like that. (This isn't about geese at all.)

To believe instead in the accruing senses, despite the fashions of any poetic year, or any self: the pupil changes, despite itself, with light; nerves trellis at the sight of any winding thing; how soon we come untongued, how near the catastrophe, castles, gore, duller dooms, all recalls something else, mistakes ...

The poet overstates? Only in context. Anyway, I liked the line you quoted because

1) It starts with an end. I wanted those poems to begin with a resting place and stir, rather than wandering to a safe exit. To show the more honest experience of — you come to a conclusion, prove something, now what? Through the emergency door — into the calm and consequential day and shrimp-flavored air and what do you know ...

2) But I should admit that "do" is probably there because it adds an iambic lilt. Conservative sound slipping an affirmation in ("form is what affirms" — Merrill)? More, I think, that attending to the syllables caught the sense I meant: a feeling less of setting an idea down than looking up after it. "I do" weds us to the present. Not the ideal but the here, the now. (The first poem in that set, not in the book, was in a less roughed-up rhythm: http://sixthfinch .com/savich1.html.)

3) Earnestly, for all my grumpiness, I wanted to believe such a present, as in that astonished and raptly emptied line, cared for with enough intent, passionately enough, could render something tender and — yes! — transformative,

an art equal to life, which of course is a curse and delight, as anything good. I look at the book now and see the record of trying this, of trying to believe it, that desire and depiction aren't failures but things one fails by not wanting them ardently enough: I do believe, I suppose, that art can do this, can record the err toward surge, the effort of nailing in place boards that let wind in, building a fish ladder so we can see the salmon leap. Words like bits of stained glass hung in stretching taffy. Which, if it's stretched by hand, becomes a way to also see the human hand. Poems like a fountain in which even the walls, even the statues sporting, even the streets leading to it — are also water, but what incredible detail on that river god's abs, how refreshing to lick. I hope the book affirms to one reading alone, who wants books to do what I hope they do: show me all I've known is real but that isn't all that is.

Vera Scekic, *Untitled (phthalo stain)*

Vera Scekic: My work aims to straddle formal boundaries and balance chance occurrences with intent. Although the primary medium is paint, I do not consider the works to be paintings in the traditional sense. Instead, I manipulate paint to investigate its chromatic and material properties, its sculptural possibilities, and its metaphoric capacity.

I am especially fond of paint that oozes, drips, puddles, and surrenders to gravity. I excise and collage these pours of pigment into hybrid organisms that evolve through accretion and serendipity. Analytically presented on monochromatic backgrounds, and inhabiting a space between the familiar and the strange, the works speak to recent developments in the life sciences that have enabled researchers to manipulate genomes and create novel species.

Modernism's grid, both overt and implied, supplies each work with a scaffold, while my quixotic search for the beautiful spill drives the process. What (I hope) results is a work that merges interior and exterior, blends science with fiction, and thrives in the gap between the artificial and the organic.

Jericho Brown

He got the idea that he could create "zombies" of his victims,
and attempted to do so by drilling holes into their skulls and
injecting hydrochloric acid or boiling water into the frontal lobe
area of their brains with a large syringe.

— from *A Father's Story*, by Lionel Dahmer

"Dinge Queen"

To straddle formal boundaries and balance chance, to paint

I do not consider sense. Instead, I manipulate to investigate.

I am fond of oozes, drips, puddles, and surrenders

To gravity. — Pour

 Pigment into

 organisms that evolve, speak

To the life science enabled, create a novel

Species, a scaffold. The beautiful spill.

Representation

HLH: Early in the book [*I Do Not Think That I Could Love a Human Being*], the terms *excess* and *absence* are juxtaposed, in a way that could read as contrasting them to one another or as making them equivalent to one another: "It's nearly always like that. / In the excess or the absence of a thing that I / appreciate it best" (p. 13). Whether they oppose, or are equivalent to, one another, though, they relate in that poem to recklessness, the speaker's expressed desire to love "recklessly." Then, late in the book, it is lamentable that light should linger in one's mind "without having properly illuminated anything" (p. 73). Is it part of the larger design of the book to juxtapose "recklessly" with "properly" in just the same way that excess and absence are juxtaposed: ambiguously, as contrasting, and/or equivalent?

Johanna Skibsrud: The book is obsessed by the desire to "appreciate … best" — to press up against the limits of what it is possible to think, to feel, to know. This is often expressed through spatial language, but the poems struggle with this. So much of what they want to say (about time, for example, or — another of the book's obsessions — love) resists being rendered, or even conceived, in spatial or material terms. As you point out, the "recklessness" with which the speaker in "In Light of This, as I've Lived on Board This Boat" desires to experience time contrasts directly with her strategy for achieving that desire — which is both retroactive and "particular." "I *do that* — [...] I do," she laments. "Imagine my moments as I first possess them / to be so small that I just splash right through / and don't notice at first, or particularly, / the space available to me there, / which only later I realize I can fill." At the root of this lament is the time-space dilemma that is explored in different ways throughout the book. How is it possible to conceptualize temporal experience through language or memory, both of which depend upon an additive linear structure and as such always arrive belatedly to experience itself? This question is asked explicitly in a poem from the final section of the book. "What toughness is it in each moment as it comes," the speaker asks, "that / grows and stretches that which was to bursting, / and becomes what it was not?" Here, again,

we see that which exceeds spatial representation, or indeed representation at all, juxtaposed against precisely the representation that it resists — or, more accurately, against the impossible *desire* to represent, impose limits, contain.

"Lament" is of course another way of framing this dilemma. The poem (in its entirety) reads:

> How sad that the light when I shut my eyes should linger in such precise formation in my mind without having properly illuminated anything.

Here "light" is abstract, but both the "precise formation" that it briefly takes and the desire for the "proper" illumination of something, are concrete. The lament is that what is abstract and immaterial, "the light," does not render anything material, become material itself, nor even be expressed through the material. The lament is that there is always, for the speaker of the poem, this dichotomy that remains at the heart of experience, between that which can be seen, spoken, recorded, or felt, and that which (though it is the very basis of that which is seen, spoken, recorded, and felt — see how difficult it is to avoid spatial metaphors!) can never be grasped, or really even "experienced" at all, at least in the way that language and memory would, belatedly, desire.

Ien Dobbelaar, *hombre y niña*

Ien Dobbelaar: The human being in all its aspects frequently appears in Ien's work.

Power and simplicity are very important in her work. She moves on the boundaries of recognizable and unrecognizable. She uses oil paint and a very limited palette, so that her work breathes peace, the whole becomes modest.

Her endeavors are to represent a deeper dimension: watching becomes contemplation.

Her three-dimensional work has the same amount of fragility. She works with different materials, such as plaster, steel, fabric. It ranges from small sculptures to installations.

The last two years she made short videos and a great number of photoseries. The subjects in her videos and photos are the elderly (the solitude, but also the beauty of the last years of life) often combined with images of small children. The feature of Ien's photowork is the way she works with her camera: she prefers simple, out-of-focus, and often black and white images.

"A piece of art gets its value by memory, remainders and reflections of a personality. An analytical approach of my work would increase the distance. By using simple images and eye-catching details I want to express a feeling of confusion about hope in this life. I try to touch the remainders of human life, left 'luggage' and human characters, and by doing so, let the viewer feel and think about it."

Michelle Boisseau

"Window Body"

Two legs aren't enough to feel
the ground under you. Like an old man,
get a good grip on a good stick

and poke what's durable.
Mud, curb, sandy road.

Give up living like a ghost,
in the mind. Leave the planet
on the table. The universe

has no edge and no center,
so stab the ground with your cane
and make your axis. The plums

are fattening again.
In the pond the ducklings
take their first swim
without a thought to their hollow
bones or greasy feathers.

The sun bursts from the curio

where you locked it.

A girl all of seven skips just ahead.

She's not from our century,

an arrow that whizzed past.

Such edges. She didn't invent

heaven, that was long ago,

during the hunger.

Most Importantly
I Have My Library

↦ THE WRITERS AND ARTISTS HERE speak of, and respond to, various repositories (the archive, the library, the palimpsest, catacombs, the list), and various techniques of reposition (to scan, to photograph, to index, to collect, to list, to cultivate). They recognize the forms of gathering, ordering, preserving, and attending that create and accompany repositories as dynamic rather than static. They understand them as *consequential*: as spiritual and ecological and civic and ethical.

The means through which they experience the repository's charge varies: meditation, observation, contemplation, interpretation, narration. Yet for each the end is some version of community or common cause: Brian Teare receives a "call to renew my bonds with the living"; Matthew Cooperman hears "all the voices piled together"; Lia Purpura finds herself "sitting shoulder to shoulder" with others.

The repository — the reposit*ed* no less than the reposit*ing* — changes the world, and changes *us*. The artists and writers here cue us to recognize the repository as "a real call [to] spiritual 'awakening,'" a site of "possible access to the Open," an "emerging spiritual language," the "boundary region" where the visible and invisible worlds merge, the place where we are "stripped of

our carapace, skin against skin," where the things of the world are revealed in their simultaneous possession of "both extreme flatness and great depth."

In the repository, through the repository, we may seek, as artist Jason Dodge seeks, to "recognize the force in things," to become our better selves by regarding things in themselves, responding to all things as Kant calls us to respond to persons, namely, as ends and not merely as means, or in Philip Metres' terms by giving up *looking* in order to *see*.

Archive

HLH: As I was reading "To Other Light" [in *Pleasure*, by Brian Teare], I stopped short at the lines, "not to suffer / more, but finally to suffer a clarity in language sufficient // to pain." I wanted to steal that as a way of stating an ambition for my own work! Is it a way of stating an ambition of your work?

Brian Teare: The short answer: yes, absolutely.

But to say so at the close of 2011 isn't the same as when, in 2005, I wrote those lines. I was at the tail end of my immersion in Gnosticism, a five-year obsession that began after I read and reread Brenda Hillman's *Death Tractates*, *Bright Existence*, and *Loose Sugar*. During my research, I had become particularly fond of James Robinson's *Nag Hammadi Library*, Hans Jonas' *The Gnostic Religion*, Simone Pétrement's *A Separate God*, Elaine Pagels' *The Gnostic Gospels*, and Peter O'Leary's *Gnostic Contagion*. I returned to those books often, particularly to the third chapter of *The Gnostic Religion*, "Gnostic Imagery and Symbolic Language," in which Jonas writes:

> Since the gnostic message conceives itself as the counter-move to the design of the world, as the call intended to break its spell, the metaphor of sleep, or its equivalents, is a constant component of the typical gnostic appeals to man, which accordingly present themselves as calls of "awakening." (p. 71)

In 2005, I was too mired in matter's metaphorical sleep to be able to imagine what a real call of spiritual "awakening" might be like — the idea must have functioned for me as more of a metaphor for the end of mourning than as a literal voice, an intra-psychic call to renew my bonds with the ranks of the living. I'm no longer nearly as immersed in the Gnostic imaginary as I once was, but rereading passages from *The Gnostic Religion* makes me realize how much crystallized during my studies. Indeed, I remain particularly identified with (1) the sense of waiting for an extra-psychic call, (2) the strong suspicion that "If the 'Life' is originally alien, then its home is 'outside' or 'beyond' this world"

(p. 51), and (3) the idea that perception, cognition, and embodiment serve as Being's central, often painful ties to a world it doesn't entirely belong to.

In 2011, the central question is: what *kind* of language offers clarity "sufficient to pain"? If I remain haunted by basic metaphysical questions and the self's relationship to suffering, this is because, where others rely on set belief systems and/or philosophies, I have assembled an archive. This archive supplies a basic set of terms with which I can describe my position, though I can never quite adopt it as my own. I remain ever alien, even to the language games I am repeatedly drawn to participate in. Why?

As William James suggests in *Varieties of Religious Experience*, "feeling is the deeper source of religion, and ... philosophic and theological formulas are secondary products, like translations of a text into another tongue" (p. 431). Attempting to translate my religious ambivalence into philosophy, I can turn to Heidegger, who in "What Are Poets For?" writes, "The poem makes no direct statement about the ground of all beings, that is, about Being as the venture pure and simple ... Rilke likes to use the term 'the Open' to designate the whole draft to which all beings, as ventured beings, are given over" (pp. 102, 106). And thus I can also turn to Edward Snow's dazzling translation of Rilke's *Duino Elegies*, to the first lines of "The Eighth Elegy," where he gives us a clear sense of the Open and its opposite:

> With all its eyes the animal world
>
> beholds the Open. Only ours
>
> are as if inverted and set all around it
>
> like traps at the doors to freedom.
>
> What's outside we know only from the animal's
>
> countenance: for almost from the first we take a child
>
> and turn him around and force him to gaze
>
> backward and take in structure, not the Open

that lies so deep in an animal's face. Free from death.

Only we see death; the free animal has its demise

perpetually behind it and always before it

God, and when it moves, it moves into eternity,

the way brooks and running springs move.

We, though: never, not for one day, do we

have that pure space ahead of us into which flowers

endlessly open. What we have is World

and always World and never Nowhere without negation ... (p. 327)

I never fail to be moved by this passage, which imagines Being as a meta-physical space. Rilke is able to describe the limited way in which most of us inhabit Being by contrasting human habitation of the World with the way an idealized and generalized "animal" inhabits the Open. In the ideal, death is behind, God is in front, and the Open is the eternal present into which the animal always moves, "Free from death." Humans, by contrast, live not in the Open but in the World; we have turned our backs to God and bounded our horizon with death, our eyes "set all around [the Open] / like traps at the doors to freedom." Death acts for us as a kind of magnetic direction, a "never Nowhere" toward which consciousness faithfully swings like a compass nee-dle: later in the poem Rilke calls this unfortunate orientation "what destiny is: being opposite / and nothing else and always opposite."

In another attempt to translate my religious ambivalence into philosophy, I can also turn to Sogyal Rinpoche's *Tibetan Book of Living and Dying*, to the chapter in which he discusses the mind, which is two-fold: on the one hand, we have Sem, the ordinary mind which is "the discursive, dualistic, thinking mind ... chaotic, confused, undisciplined and repetitive," and on the other hand, we have Rigpa, the very nature of the mind, which is "absolutely and always untouched by change or death ... intelligent, cognizant, radiant, and always awake" (pp. 46–7). When I first read this passage, I was struck by

parallels between the Tibetan Buddhist terms and Rilke's elegiac diction: Sem and World / Rigpa and the Open. While it is too neat to posit the terms as exactly analogous, certainly Buddhists would agree that our ordinary minds are set "like traps at the door to freedom," and that it is our negative relationship to change and death that keeps us feeling that "What we have is World / and always World and never Nowhere without negation."

I'd like to risk posing another analogy based on the Tibetan Buddhist terms: what if ordinary everyday language behaves for us as a kind of Sem, and what if poetic language can, at its best, function as a kind of Rigpa? I like to think that poetry can indeed function as a "counter-move to the design of the world, as the call intended to break its spell," and that language de-familiarized can at once make us newly awake to the nature of the mind-in-language and thus the mind-in-the-world, an awareness as potentially revelatory of politics or ethics as of theology. If, as Sogyal Rinpoche suggests, successful meditation means that one's mind is "attentive to … a state of Rigpa, free from all mental constructions, whilst remaining fully relaxed, without any distraction or grasping" (p. 159), I like to think that a successful poem can likewise generate in its reader an analogous state of negative capability, "when a man [*sic*] is capable of being in uncertainties, mysteries, doubts, without any irritable reaching after fact and reason" (Keats, p. 43). I like to think that the one who thus returns from this kind of state does so with the ability "to suffer a clarity in language sufficient // to pain."

If this is true, then a certain kind of successful poem might function somewhat like Buddhist meditation; it might encourage us to counter our immersion in Sem and urge us toward an encounter with the discursive limits of the ego and consciousness both. Take, for example, the following poem from Red Pine's translation of *The Zen Works of Stonehouse*. Though it begins with a somewhat dutiful rehearsal of Buddhist tropes concerning mind and illusion — the mind with its aimless ordinary thoughts = sky through which clouds move = water through which leaves drift — its unexpected closure cracks me up every time:

The shame of dumb ideas is suffered by the best

but lack of perception means a fool for sure

among those who say it's all illusion

who sees that wealth is due to luck

leaves in the stream moved without a plan

clouds in the valley drift without design

once I closed my eyes everything was fine

I opened them again because I love mountains (p. 27)

Because we do love the World, don't we, though it's dumb to love our destroyer, and thus despite our meditative practice we open our eyes to the World. But at least at the end of this poem we open them *knowing* "the shame of dumb ideas," as opposed to having a "lack of perception" about the end results of our attachment. Stonehouse's poem highlights two of the things I like best about the practice of Buddhist meditation: (1) it allows me to experience embodied or cognitive states as though from without, sometimes even without suffering; (2) viewing embodiment or consciousness from the vantage point of detachment allows not just for potential insight but also for a kind of compassionate humor that is largely absent from Western religiosity. This is the reason why in 2011 I study Buddhist theology: it gives me hope that rather than remaining at the mercy of the World, there is after all possible access to the Open.

WORKS CITED

Heidegger, Martin. *Poetry, Language, Thought*. Translated by Alfred Hofstadter. New York: Harper & Row, 1971.

James, William. *The Varieties of Religious Experience*. New York: Penguin, 1982.

Jonas, Hans. *The Gnostic Religion*. Boston: Beacon Press, 1963.

Keats, John. *The Letters of John Keats*. Edited by Robert Gittings. Oxford: Oxford University Press, 1970.

Rilke, Rainer Maria. *The Poetry of Rilke*. Translated by Edward Snow. New York: North Point Press, 2009.

Rinpoche, Sogyal. *The Tibetan Book of Living and Dying*. San Francisco: HarperCollins, 1992.

Stonehouse. *The Zen Works of Stonehouse: Poems and Talks of a Fourteenth-Century Chinese Hermit*. Translated by Red Pine. San Francisco: Mercury House, 1999.

Thomas Lyon Mills, *Caroga*

Thomas Lyon Mills: In her novel *The Abyss*, Marguerite Yourcenar quotes an alchemical dictum: *obscurum per obscurius; ignotum per ignotius*, which roughly translates, "proceed toward the obscure and unknown through the still more obscure and unknown."

Since arriving in Rome over twenty years ago, I have found the lowest regions of this city's palimpsest to be the startling equivalent of my dreams.

My Roman studio remains the Ipogeum of the Colosseum and its watery tunnels from which I have fanned out to work in many closed mithraeums, those man-made caves of the astrological cult of Mithras, and certain catacombs closed to the public where I have rare permission to explore and work alone.

What do I find underground? A quiet so complete that I can hear my heart beat, in mazes with dank odors and icy humidity. Skeletons, nearly two thousand years old embrace one another in their tombs, and, if disturbed, would turn to dust. Paintings and carvings are enigmatic messages in the darkness. And I find the strangest of wildlife. Long, wormlike creatures with millipede-like legs coexist with ten-inch-long phosphorescent mantises that give off an eerie green light. Half-inch milk-colored poisonous spiders crawl into my shoes and make me a regular customer at the pharmacy. Transparent spiders the size of my hand make clicking sounds on the walls of the silent tunnels. Aphids skitter by the thousands up stalactites as they flee from my lights.

Back in my Providence, Rhode Island, studio, I extend my on-site work further by building three-dimensional models. Animal bones and old tools substitute for on-site trees and stumps; stacks of abandoned mud wasp houses peppered with oblong tunnels become archeological labyrinths in miniature.

My sketchbooks form an archive of images from museums, archeological sites, landscapes, and, perhaps most importantly, a catalog of my dreams, begun over thirty years ago. My dreams have proven to be disturbingly prophetic: harbingers of where I need to go next.

I am working on one thing only; my inner world, where time is nonlinear, elastic, continuous, and circular. Trees and mosses become tunnels and architecture; ghosts levitate and walls dissolve. This is my preferred world, the shadow world of memory, time, and dreams.

Perhaps the Russian mystic Pavel Florensky describes this boundary region best when he writes that "... we experience moments ... when ... two worlds grow so very near in us that we can see their intimate touching ... [where] the veil of visibility is torn apart, and through that tear ... we can sense that the invisible world (still unearthly, still invisible) is breathing: and that both this and another world are dissolving into each other."

Evie Shockley

"beneath this city there"

is another city where your eyes

must learn new tricks

can you see the ragged pillars rising

to be read like library stacks

the plank bridges

that lead escher-like

to the inverse of certainty

the rips in space white plumes

through which one may pass

from subterranean world

into other world other ness

lake in which the ground

on which we sometimes walk

appears as dark and earthen skies

god hovering horizontal

faintly wasteful or generous

to the point of dissolution

all give way to the clouds

of other

orientations to the textured

vacuum that reveals

the underworld's spidery

cave upon leaving a haven

wade into that great blank

whose nothing yawps

before you like an unconfessable

crime *caroga* marking

the last stop

in the mud of the familiar before

the no place you've heard

called *home* breathes you in

to the thick condensation of

a multitude of sighs

competing with the cold

Scan

HLH: Your book *Still* includes many lists; in a certain way, it is itself a list. Many lists in themselves have an oddity to them that makes me shift my perspective slightly. (I'm thinking, to choose an example almost at random, of "Pain Reliever" on p. 51, which starts as I'd expect, with Tylenol and Advil, but then begins to include items I wouldn't normally classify as pain relievers, such as PlayStation and Oakley.) In other cases, it is the juxtaposition of two or more lists that jolts me. (Here I'm thinking, for example, of "American Facts" on p. 66 and "World Facts" on p. 67, with their lists of facts about eating disorders in the United States and malnutrition globally.) This is the "information age," in which we have access to more facts and more lists than a person could possibly digest; what, from your point of view, is the importance of the kind of gathering and arrangement you have undertaken — and offered your reader — in *Still*?

Matthew Cooperman: The work of *Still: of the Earth as the Ark which Does Not Move* is archival. Something of the present moment — or more accurately of the last decade, as it is a book of a decade — seemed to require an accounting. A list, to be sure, but also an index, a frame, a capture. The gathering you speak of is a belief in occasional poetics. It's really been a duration piece, a document project. The first poems were written in the late 90s, as far as I can tell '98. The latest are from 2010, so the book's had a long slow arc, if you'll pardon the pun. I found the poems an effective place to dump all the "unpoetic" thoughts I had of the world. I mean, so much shit happened from, say, late 90s, late Clinton, to now, mid (or late?) Obama. And so much of that information seemed more forceful than lyric utterance. I've always been attracted to the political poem, but I wanted some place where the information itself, the data, could reside. And equally, some place where the heroes and criminals of that period could actually speak.

That necessitated some kind of new form. The obvious analogy is to photography, and for a long time I thought of the book as photography, and I wanted to work with a photographer. The syntax of all that "capture" became an impulse

to scan, to incorporate. A paradox of moving stills. This also came out of my reading of Husserl, from whom I have mongrelized the title. His insight into earth, into ground — that it is the foundational principle of all our senses of space, is really quite simple. The ark of the earth does not move. It is, as object, as body, prior to any conception of space. And the earth is our larger body, we are aspected earths. This I think quite profound paradox somehow operates against the scientific description of earth, which is that it is spinning madly around one gravitational object (the sun) which in turn is spinning madly around yet another gravitational subject (the galaxy), and so on. The paradox is enough to make you crazy. But it's also how I feel these days, the intense ecological disaster, which is also ontological. There's a wobble going on.

All that's put pressure on the colon. *Still* manages this paradox by the colon. Or the index, and the equational balance that the colon offers. It's a list, but it's apposition, metonymy. Epic catalog becomes daily catalogs, inboxes and mailboxes … stuff. It's hard to breathe, but there's something democratic in that, too. The book's like an enormous garbage heap, with all the voices piled together. The way things "go viral" in our time means the sources of statements — or the veracity of "facts" — are always moving at lightspeed. Benjamin's entourage has its own reality show, or, to quote from Balzac, who himself is quoted early in *The Arcades Project*, "The great poem of display chants its stanzas of color from the Church of the Madeleine to the Porte Saint-Denis." I love the spatiality of all this, literally hi/low, no boundaries.

It went on and on, a kind of subterranean project of subjects that seemed necessary to write about; and that anything I had to say about them was really just the tip of the iceberg. I loved that aspect of writing the poems, even as it became an enormous physical burden, trying to sift the ways of dealing with the ostensible subjects. Which subjects? What are the categories of experience? Of purchase? Of actions? These days the menu is limitless.

Bruce Checefsky, *#13*

Bruce Checefsky: To create the images in this new series, I customized an optical scanner by stripping the device to its bare essentials and replacing the cathode flourescent lamp with a more powerful bulb. I mount the scanner to a tripod by drilling a hole in the plastic carriage. Powering it by a lengthy extension cord and connecting it to a laptop computer, I take the modified scanner and computer into my garden and open toward its surroundings to register close-up images of the landscape. I effectively "scan" my garden, repurposing the photo scanner as a field camera.

Digital images exist as mathematical data, obtained and displayed by sequential scanning, shifting the semiotic code to alter the relationship between original and copy. The scanning glitch, or "utterance" in the picture is a result of the scanner moving across the object while recording and suggests a shift in the technological language similar in many ways to a spoken word.

Mary Quade

"Camera as Jophiel"

Man, like zinnias, common and unlikely.

Night in the garden, the two aflame.

The photographer captures the secret,

the firecracker the moment before it falls.

To be caught, to show both

sides of their petals — a release.

Something rustles into its hole.

Butterflies dangle out of sight, quiet,

but this isn't sleep. He can't quite

hear her; he leans, but she's only

moving her lips. Crickets throb.

Moths smother honeysuckle.

The photographer collapses the tripod.

Something has happened, but

no one is yet sure what.

Things

HLH: I am repeatedly drawn in these essays [*Rough Likeness*, by Lia Purpura] to the lists they contain. (As, for example, the lists on pp. 29–30, 43, 67, 73–84 [the essay is structured as a list], 86–7, 147–8.) To what extent, or in what way, is the *list* a synecdoche (a microcosm? an analogy?) of the *essay*? In asking the question, I have in mind places at which you may already imply an answer, such as at the end of "Gray": "And here I am, outside, giving thanks. ¶ I'm starting by noting every gray thing" (p. 96).

Lia Purpura: A list is a savory thing. In a hearty list, objects mingle and bump up against: think *winter soups*, not *consommé*.

Think *string of beads*, not *monomythic pearls*.

Things lead to other things and clear a *way*. Like rocks in a river — once you start crossing, you find the next spot just ... there, underfoot. And by hopping, the far bank is now near.

A list is a compact and functioning system. In the world of the list, simultaneity (the cloudlike) and suggestion (path-loving) cohere. A list both raises and answers questions: *how do* and *here's how* things go together. (By all existing on a street in rain. On this day. In this town. All wet and lending their angle of shine. All are east facing. All smoky-but-doused, say, for example.)

The likenesses a list offers mean: we are linked. How inevitable we seem, sitting shoulder to shoulder. The further implication? *Proximity* is civic in nature. Nearness lets a thing lean over and speak. Speak up *for*. Intervene. Alone in a car, how easy it is to rage at another. Stripped of our carapace, skin against skin, how much more likely to accept an apology (and offer one, too). To sidle up to. To let offense go.

A list makes a whole where parts had been, while also loving the shimmer between — like many glasses held up to the light: all those lit jewels soon to be sipped from. All the commingling luck and good wishes.

As a gesture, a list doesn't "speak its mind" as much as it "lays its cards on the table." A list would rather play than argue (and very much rather find its own mind, than inherit ways-of-saying).

Milling, massing, pressing ahead, a list is a crowd worked into line. One becomes sort of helpless in the midst of a list, as I am now — both caught up in and buoyed along by.

In the end, collectors want to share their stuff, to have you come by, and visit, and admire. A line of tin soldiers. Creamers on a shelf. Mandibles in a Riker's box. In the end, what collectors amass are stories. Stories body forth well in things. Are en route and lively. Thus assembled, objects in a list (the list, a writer's collection) are always whispering into the ear of their neighbor. Touching their neighbor. Jostling, shadowing, careening off. Sweating on. Eavesdropping on. Waiting their turn. Doing their part. Telling a story that wouldn't otherwise be, that would remain disassembled, floating free, unembraced, as is the fate of so many unaffiliated things.

Jason Dodge, *Above the Weather,* 2007

String, wire, rope, electrical cord, and other items that are measured in a length totaling

the height of the distance from the surface of the earth to above the weather.

Jason Dodge: I am interested in trying to recognize the force in things, not by changing them, but simply by recognizing the force in them.

Philip Metres

"The Weather"

The snows fall slow,
As if the world were an eye

Beginning to close.
And though it reaches

To sky with every surge
Of its limbs, the old tree lists

Slightly from years
Of giving in to wind.

From a certain distance
Everything's confection:

The blind-white nerves
Conducting their daily siege

Of my brain, a child's bruise
Purpling around her eye,

The daily missiles delivering

Their attendant splash

Of multicolored tropical light

In runted mountains.

But could we reach up

With coils of cord,

Could we hoist ourselves

Above this weather,

Would we stay in vacant

Sky forever, or descend

To our daily socket ends,

Where our bodies long

For what the eye won't see

Until it gives up looking?

Only Rearrange the Stones

⊢→ IT IS REMARKABLE how little we *think* about time, how readily we accept as definitive and complete a way of construing and experiencing time that in fact is culture-bound and (at best) partial. Most typically, we take time as uniform (measurable, in mechanical units such as seconds and hours), purposeful (having no *intrinsic* value but instead valuable only extrinsically and instrumentally, for what we can accomplish with it or gain from it), and linear (progressive, moving insistently from a beginning to an end, never returning or repeating).

The artists and writers in this section, though, share a sense that a rigid and narrow concept of time constricts experience and understanding. They see that the currently typical concept of time prioritizes work over leisure (if one is not *making use of* time, one is *wasting* it), objectivity over subjectivity (there is an "only" in "That meeting only *seemed* long"), and quantity and increase over other forms of value (leaving as meaningful only such expressions as "that takes too much time" but not, say, "that does not enrich time"). Alongside, or even in place of, that pervasive concept of time, these artists and writers substitute a time that *repeats* in addition to *progressing*, that relates to the *imagined* no less than to the *real*, that has *pattern* as well as *purpose*, that sees *cycles* and

entanglements no less than *direction*, and that includes not only the *visible* and *audible* but also what is *hidden* and what is *silent*.

Their willingness to envision time in nonstandard ways leads the artists and writers here to alternative ideals and apprehensions, as when Andrew Joron observes that "the imagination alone can access the world's unrealized possibilities," when Scott King seeks "a bodily connection between pattern in language and pattern in nature," or when Phillip Michael Hook seeks both to array sensations in a form *and* to bury himself "within, or beneath, those sensations."

The sages in this section suggest that such possibilities as visionary experience (Stein), sanctuary (Conoley), and integration (Trilling) are conditioned by a capacious and multiplex, rather than a narrow and singular, understanding of time.

Repetition

HLH: The repetition in this book is uncanny, as the title *Uncanny Valley* [by Jon Woodward] suggests, but I wonder if, in addition to the title, another clue to the work repetition is performing occurs on p. 13, with the line "No narrative momentum." My impulse as a reader is to emphasize "narrative" and to add an implicit "but ..." onto the line: No *narrative* momentum, but Would you as the poet condone that impulse? I.e., are the poems after some other kind of momentum (one to which repetition contributes) rather than after the rejection of any kind of momentum?

Jon Woodward: Your question made me start thinking about "narrative momentum" and what that might mean. "Momentum" must have something to do with how we experience time, the moment, in the poem.

A poem binds time* through various means. One of the most common is narrative (broadly considered): characters persist through multiple events much like people persist over time, and their actions in the past have predictable (or "lifelike") consequences in the future. The momentum that one feels while caught up in a narrative is, I think, the experience of bound time running alongside actual (external, unbound) time, and that's a truly magical thing!

And I think that in my book *Uncanny Valley*, I do make some use of narrative time, but I'm also trying to bind time in other ways, often concurrently (or overlappingly) with the narrative. As you suggest, the stretches of repetition are the most prominent. Repetitions of words or lines establish a wholly other engagement with time. These repetitions appear as bubbles or cysts of trance-

*The "binding" of time is a bit of vocabulary that I'm borrowing from composer Chris Dench, specifically from his essay "Time-Travel" in *Arcana II*, edited by John Zorn, published by Hips Road/Tzadik. The essay doesn't answer or solve anything for me, but gave me a term to use when thinking about these things.

time, of an ever-present, in otherwise narrative contexts. The "lifelike" causality of past-present-future finds no purchase inside them. Their momentum is unique to them: the pulse of words turning into pure sound, into heartbeats and lungfulls. Which I also think is completely magical. And I think that these two modes (narrative and repetitive) change each other in strange and productive ways, when interspersed and interleaved.

So, short version: rather than "No (narrative momentum), but ..." I would say, like any beginning improviser, "Yes, and ..."

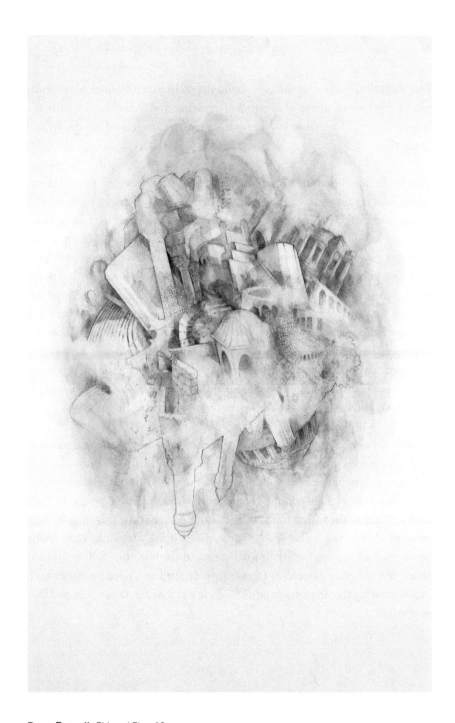

Doug Russell, *Ebb and Flow #2*

Doug Russell: I build imagined, improvised, and invented realities which grow out of my love of direct observational drawing and a fascination with the universal cycle of germination, growth, expansion, overcrowding, decay, and renewal.

This meditation upon the cycles of manmade construction and natural decay stems from my two-year experience living in Turkey, a country to which I still return and explore every other summer with my students. In Turkey there is an overwhelming and immense wealth of ruin and renewal. Anatolia has seen numerous civilizations wash across its soil — from the Etruscans, Hittites, and Greeks, to the Romans, Byzantines, and Ottomans. Each laid down its foundations upon the previous — obscuring, revealing, destroying, and reusing whatever came before. Today the dense and layered landscape that remains bears physical witness to this epic ebb and flow of each generation's hopes and desires, failings and limitations. As each civilization rose and fell, it echoed a grander and more universal pattern — expending immense energy to create and maintain an ordered reality, succumbing to inevitable collapse and decay, and ultimately giving way to unknown future empires.

In the "Empire" and "Edifice" series of drawings, I explored a spontaneous and unrehearsed approach, building images of invented elemental forms of monumental architecture simultaneously coming into and fading from existence. This process often continued to a point where the image eroded to leave only vestiges of the initial form. In the "Empire" series the drawings usually resolved themselves within a day, while the "Edifice" drawings took nearly seven years to develop into their final states. In the ongoing "Ebb and Flow" series, individual architectural forms are multiplied and piled on top of each other, growing like impossible cities — living and dying, expanding and disappearing.

Andrew Joron: Painting and architecture both articulate a poetics of space: visual space in the case of painting, and environmental space in the case of architecture. Both have something to say about space — but painting *about* architecture takes the conversation to another level. In the Renaissance, painters created a new visual vocabulary from the perspectives of classical architecture, and in a feedback loop, used these perspectives to portray architectural subjects in the golden light of the golden mean. Nonetheless, even after the invention of perspective, spatial depth in painting remains a mere reflection of reality, whereas in architecture the play of depth takes place in reality itself. Painting, in the syntax of architecture, is a window onto another world. But the space of architecture is the space of the world itself. Painting operates at a remove from the world: it is a kind of writing, a series of marks whose interpretation revises only subjective space, whereas architecture revises *both* subjective *and* objective space. Is painting therefore a lesser art? The practice of certain artists, like Piranesi and Desiderio, in representing a fantastic architecture — imagining edifices that could never be constructed in the real world — seems to offer a riposte to architecture's claims to completeness. For the depiction of fantastic architecture reminds us that reality is incomplete, and that the imagination alone can access the world's unrealized possibilities and, more than that, the impossible itself. Architecture can only rearrange the stones of the world, whereas painting can imagine a stone suspended in midair. Architecture is finally forced to reconcile itself with the world's dominant powers, both physical and socio-economic. Painting need not do so. In Doug Russell's paintings, architectural forms conglomerate in a non-Euclidean space; indeed, the admixture of elements from different architectural eras bespeaks a nonlinear temporality as well. Yet, space-time in Russell's work is not so harshly fractured as in the work of the Cubists and Cubo-futurists; instead, Russell's nonlinearity is more cohesive, more organic, as if a naturalism of a higher order was being formulated here. The tonalities belong to the same register, shading and seeping into one another: it is a pale, history-colored light that pervades the scene, a scene autumnally stained by the blood of that eyeless, weightless Vitruvian animal whose portraits these are. Here, there are only exteriors swinging around an invisible interior: the center holds so long as it remains invisible. Every building its own dynamo! If the entrances are entranced, the exits cannot exist.

Pattern

HLH: Two aspects of your book [*All Graced in Green*] seem to me in dynamic tension: in subject matter, the "natural" is a pervasive presence (most obviously in "Physiologus," but throughout), but in technique, alliteration, what many people would consider an "unnatural" or "artificial" language pattern, is prominent (most obviously in the selections from "Wynnere and Wastoure," but again throughout). Why are they together in this book?

Scott King: Let me start with a quote from your recent book, *Lines of Inquiry*, to orient my response and to step in line with your thinking about poetry. In thesis #84 of "Is Not" you suggest that "poems are a technology that furthers our ability to perceive and understand reality," and that "formal devices [are] the 'lenses' of the poem." Using this metaphor, alliteration is a lens, and a vintage one at that. The glass of this lens, ground many hundreds of years ago by anonymous craftsmen, imparts a texture, both aural and visual, upon our perception of reality.

There are fingerprints and smudges all over it, put there by poets such as Shakespeare, Dunbar, Blake, and Hopkins, and more recently by W.H. Auden, Dylan Thomas, Thomas McGrath, and others. It passed into my possession almost by happenstance, nearly dropped from the pages of *Endeared by Dark* (Porcupine's Quill, 1991), the collected poems of George Johnston, when I opened that book to the alliterative poem "Ecstatic":

> When basswood blows bees make in it,
>
> mill in midsummer myriad pillage;
>
> probing to pull out pollen and sweetness

Of course this fancied literary lineage doesn't exactly explain why I've placed the subject of nature and the technique of alliteration together in my book. So let me start again.

First, there's the precedent of previous poets. In fact, many of the poets I just listed have used alliteration to great effect in describing the natural world. Think of *The Pearl* poet who wrote in that poem of how "The glittering meadows, the woods and water / all healed me and drove out the dark of my sorrow" (Draycott translation). Think of Hopkins who wrote, in "The Windhover," "I caught this morning morning's minion, kingdom of daylight's dauphin, dapple-dawn-drawn Falcon, in his riding ..." Think of Thomas McGrath's "Green permission" given in his long poem *Letter to an Imaginary Friend*, "Juneberry; box elder; thick in the thorny brake / The black chokecherry, the high broken ash and the slick / White bark of poplar." The odd man out, seemingly, is W.H. Auden, who pointed the lens of alliteration in the opposite direction in *The Age of Anxiety*, describing life in the city in time of war, arranging the quotidian and the mundane world of man into music. But even there we find lines such as these: "A world of detail. Wave and pebble, / Boar and butterfly, birch and carp, they / Painted as persons, portraits that seem / Neighbors with names; one knows from them what / A leaf must feel ..."

Second, there's a bodily connection between pattern in language and pattern in nature (see Brian Boyd's *On the Origin of Stories* and *Why Lyrics Last*). Even though language, when held up to nature, might seem artificial, a step or two removed from bird call or beetle click, the patterning of language mimics — at least to some degree — the sounds and repetitions one hears in the woods and fields. Think of the clever mnemonics devised by ornithologists to remember bird songs: the white-throated sparrow's *Old-Sam-Peabody-Peabody* or the hermit thrush's *O-holy-holy! O-clear-away-clear-away! O-clear-up-clear-up!* (the latter from John Burroughs). Alliterative poems, with their repeated and recurring letters, with their run-on and ringing lines, might, in this one aspect, be less artificial than the patterning of language encountered in other verse forms, say sonnets or sestinas. I think the combination of sharp observation and linked letters is not so much unnatural as undervalued, though admittedly somewhat out of fashion. There's no reason to judge this combination ineffectual or slight, but rather an attempt to capture a richness with richness.

Mostly, when it comes right down to it, I simply step over the "explanatory gap" and write the kind of poem I want to write, preferring a poem that clatters and accumulates both sound and sense, that is messy, yet meaningful, something akin to the road dust, the glittering and bouncing tools, and the work gloves that cluttered the dash of the station wagon I rode in on the farm as a child. Like the bee in Johnston's poem, I want to probe and pull out a certain sweetness, to make "myriad pillage" of the world. Alliteration is one very good way to heap this pillaged sweetness into a poem. In addition to the generic "tree" you get the buds and branches and bark, all the names and then some. So, out of sheer enthusiasm, I've played up the alliterative line throughout my book, finding it to be a good fit and a pleasure. And, as Gertrude Stein so stylishly defended the craft of writing, "Why should a sequence of words be anything but a pleasure?"

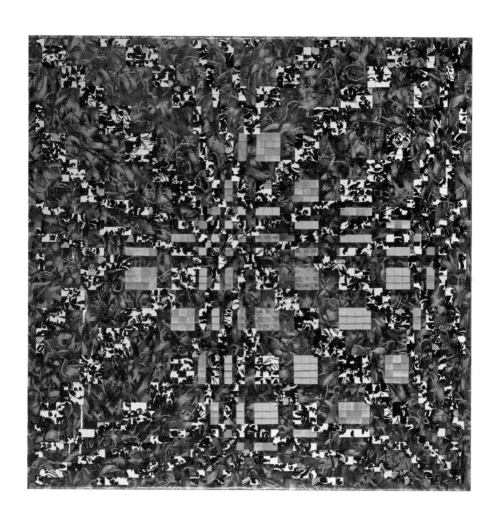

Gerry Trilling, *Hidden Minority*

Gerry Trilling: My work is concerned with the relationship of perception to organized systems of information. A summer spent in New York City engendered a profound awareness of infrastructure potential — both fragmentation and integration — which had a powerful impact on my work and led me to investigate the idiosyncrasies of patterned compositional structures within the visual field.

In 2010 I began using a patterned overlay to metaphorically illustrate how information can be filtered. Used in that way, patterning encourages a false sense of order even as it disrupts experiential perception. I want the viewer to be aware of both the construct and what is hidden from view, though I believe people will always try to integrate both experiences into one reality.

Nin Andrews

Only when you were gone did I hear your footsteps behind me and turn quickly,

expecting to see that smirk on your face, not some stranger walking fast.

Only when I stopped looking did I see you in every café or passing train.

Only when I tried to be sweet, to say, *It's okay, don't worry*, did I taste the salt and

bitterness on my tongue.

Only when I said *never again* did I wish and wish, *just one more time*.

Only when I waited for the mailman for letters you never wrote, did I think

what an asshole you always were.

Only when I became an insomniac, remembering your scent, your touch beneath

the sheets, did I listen for hours to a solitary cricket rubbing its legs together,

its song of ache and throb and lust.

Only when I was starving did I swear I would never taste, lick, drink, sip again.

Only when I swore off men (they're all such shits, don't you think?), did I say,

Okay, I give in. (It was with a stranger with a body like yours, though it's true,

I can't recall his name.)

Only when I knew there is no god, no truth, no afterlife did I finally learn to pray.

Only when I told the truth did I realize it's the lies that save you in the end.

Only when the snow kept falling did I see no one can make it stop.

Only when I was lost in my own house did I think, this is not my home.

Only when the sun finally rose did the shadows fill my rooms.

Only when I left for a small town in the south did the city light up around me,

like a blessing, like a curse.

Spacing

HLH: On the second page of "4th" [in *an oh a sky a fabric an undertow*], part of one line reads, "the war does not space itself"; but this assertion appears in a poem that *does* space itself, one of a collection of poems that space themselves. The title "[PEACE]" is used for several of the poems. In this book, what is the political importance of spacing? What is the relation of spacing to peace?

Gillian Conoley: Very interested by your idea that spacing is part of the *politics* of the work. The use of spacing in my work came out of a long evolvement over years of becoming conscious of the page as its own entity, as an element of the poem, not a substance onto which the poem is placed. I found that using space allowed me to experience a poem in a different way, that it let in the actual act of perceiving in its own time (not after the fact) which is something I hope transfers over to the act of reading. Using space also allowed me to slow down the act of writing and perception. So it was more than playing with sound and duration and the visual aspects of the poem. Mallarmé, Cage, Apollinaire, Olson, Eigner, Albiach — all these poets are important to me as to their various and differing uses of space and the effects and experiences they came to.

But the *politics*. In this chapbook (which is part of a longer manuscript I've just finished called *Peace*) there is a kind of open capaciousness that started to happen. Thematically what is being sought in the book is the question of how does one live in a country/world of nonstop war. Does that mean there is no more peace, how are war and peace co-presences in the world, is that possible, what might this do to awareness?

So the line in the poem "4th" that you refer to, "the war does not space itself" appears in a poem that has a lot of space both within the lines and between them, lots of drop-down sensations, etc. When I look at that line it has a speed and ferocity about itself (as opposed to the others in the poem, which are much more slowed down and tentative) that it makes me think that the line "the war does not space itself" is analogous to war itself: relentless, fast, firm, present,

insistent, and that as experience it is unyielding. So here I think we could say that the lack of space in that line works to make the line an action that is analogous to the action of war. Whereas the other lines in the poem depict a floaty sort of 4th of July with a family that is both inside and outside the house, a lot of interior and exterior going on individually and collectively, and one can hear someone mimicking Janis Joplin in a fair down the street, while there are "two teenage girls at the screen with the sun in their eyes" and then comes that big drop down of space and here comes "all day time takes / all the time bright canisters in the culverts girls read / hills of it."

In the middle of all this domesticity, the place of the home in the world, a place of sanctuary (peace?), on a day made by war, the 4th of July, "the war does not space itself." Which throws the notion of the home as sanctuary, the presence of peace, into an angle of relief and illusion, momentarily — a lot starts to go on in the spatial and temporal — a balancing and counter-balancing — a tension or struggle between the two.

This brings me to your next question, "What is the relation of spacing to peace"? On a physical level, I experience those lines (the "two teenage" lines on down) in a much more gradual, open, slowly arriving way, much more tentative and unsure of themselves as they find their placement in the poem. So the notion of peace is coming in more tentatively, hesitantly, quietly, and yet it is there, making itself manifest.

In terms of material, maybe space is trusted more than a straight word-impacted utterance. Maybe space, emptiness, void, allows something else to happen. If we look at regularized syntax and "norm" of utterance as a kind of power, maybe space lets us break down or circle around that power. Or be present around it. Or maybe not, but that's part of the inquiry of the work.

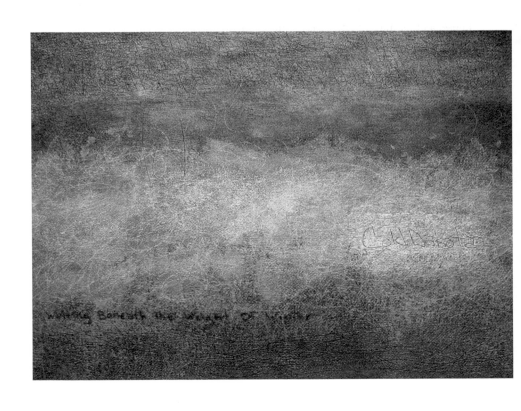

Phillip Michael Hook, *The Weight of Winter*

Phillip Michael Hook: I think of my art as a recording of my time in the studio, a physical space and a mental space, a place where without distraction I can bring together the array of sensations I experience into some kind of physical form. I think of the work as autobiographical in that I borrow from my life, my emotions, my loves and interests, my reactions and interactions with my environment. There are moments in the studio when I feel I've entered into a place the painter Squeak Carnwath refers to as "Subterranean." When I am making work with which I'm satisfied, I will feel comfortably buried within, or beneath, those sensations, attempting to glean meaning from that creative space. My art is where I resolve troubling thoughts, where I celebrate my joys, and where I place hope (Silent Bids) in my future.

Alex Stein

"The Weight of Winter"

Without recourse to the image
almost all visionary experience
would be lost from communication.
The great migration, every year,
of the geese, their honking elation,

how shall one say that one's soul,
flying with them, has crossed
to the world beyond the world,
without seeming to insist: "I am,"
without seeming to pronounce: "I did,"
without screaming: "See me, now."

Six geese and then twelve and then six dozen
cross the high gray sky. A brass band — but is it they
who are tin of ear or is it we who do not appreciate
the avant-garde crescendo of their transit?
The call to migration bestirs the house. You
who do better for yourselves by it, feel free
to concentrate upon the blue rhombus or the white ovoid,

but as for me, I seize the center of my mind,

when I hear the migrating geese call,

and I concentrate upon the lotus blossom.

Migrating geese!

Past winters,

were there so many?

Here Long Enough to Disappear

⤳ MY OWN IDENTITY partly depends on, is partly constructed by, my response to others, and vice versa. How, then, make myself — my understandings, my dispositions, my actions, my affects — *responsible* to others? How to respond to others such that my identity is enlarged by theirs, not theirs reduced to mine? The interlocutors here pursue those questions.

Veronica Golos, for instance, thinks in terms of a "leaning forward," toward those against whom wars have been conducted in her name, a calling-by-name of persons war seeks to un-name. Alisa Henriquez ventures to create a reflective space out of the very forms and determinations that work in our society to forestall reflection and preclude reflectiveness. Sreshta Rit Premnath engages, and by engaging resists, rigid and rigidifying "matrices of knowledge, power, subjugation, and mediation." Jane Lackey explores alternatives to those rigid matrices, in the form of networks of interrelationship, "systems of fluid affinities and alignments."

To accomplish, or even (more modestly and perhaps more realistically) to *move toward*, such ideals, the artists and writers here hazard questions rather than imposing answers (Brown), "squint hard at what's not there" (Di Blasi), dedicate themselves to possibilities not yet realized (Taylor), and engage themselves to imagine *here* what can be imagined "not without fear but without hopelessness" (Moldaw).

Though it long precedes this book, William Meredith's sestina "The Jain Bird Hospital in Delhi" shares with the conversants here an attitude of inquiry into how one might make oneself responsive and responsible to others. As if to concur with Klaces' attention to what is "wrapped in wings," Meredith's poem regards us as "sky-clad," finding thus in our veriest vulnerability our most capacious possibility.

Complexity

HLH: Near the middle of your book [*Rust or Go Missing*], there is a poem called "Knower," and near the middle of that poem is the sentence "Here, / my trick: accompaniment." I don't mean to make too much of one moment in the book, but I wonder about the importance — for you personally, for this poem, for your book, for the project of knowing, for our culture — of "accompaniment." (Just as one for instance, do the quiet woman and loud man in the title poem accompany one another, or *fail* to accompany one another?) I *think* this is a question, but in any case I'll be interested in any way you choose to respond.

Lily Brown: The issue of accompaniment is a loaded one for me, and I think you pick up on my ambivalence with your question about "the quiet woman and the loud man" in the title poem from my book. I observed those people in a coffee shop in Berkeley, and while I have no real way of knowing whether they did or did not accompany one another, the exchange got me thinking. I was actually touched by the conversation because the man seemed to want the woman to know she would still have her coffee to accompany her, even if he went to the restroom. Perhaps he was projecting his own worry about leaving her in his utterance. Or perhaps he himself was not a person who liked to be alone. *Or* maybe he liked to be alone, but was concerned about what that meant with regard to his significant other. By transcribing that exchange and then giving it a sort of metaphorical equivalent in the poem ("He says, *while you enjoy your coffee, / I'll go to the bathroom. // He says, here's the light. I place it in your glass. / Here's how light stays when I'm gone.*"), I wanted to raise questions about accompaniment, and maybe highlight its complexity, rather than provide answers. I see that as an issue with cultural significance, actually: to give space to questions, rather than answers, and to complicate notions of identity and relationships.

In the book as a whole, accompaniment has two referents. The first is, not surprisingly, other people. How do we (and, indeed, do we) accompany others — family members, partners, friends? What does it mean to be in relation to others, and what do we need or not need from the people in our lives? On

a personal level, I struggle with carving out space for myself in relation to others, so I'm constantly mulling these questions over. One of those questions, in fact, has to be whether it's even possible to conceive of oneself as an independent entity, free of one's origins or influences. The answer, I think, has to be "no," but that doesn't mean that being-as-accompaniment is always comfortable.

The other referent is writing itself as accompaniment. The two referents, though, are intimately intertwined, and necessarily so. If I remember correctly, I may have been thinking about both when I wrote the poem "Knower," with the lines "Here, / my trick: accompaniment." Writing is a way of asserting identity or finding space for oneself in the world, but it's also a way of reaching out to others, both real and imagined. I have a few friends I share poems with, and when we send poems to each other, I always see that as an act of trust, of community, and, indeed, of accompaniment. The same goes for the writing classroom. A group of freshmen I taught recently all wrote in their final reflections about how important peer feedback was to them in learning about their own writing. When they worked in small groups, they would get into these heated discussions about each other's writing, and that was wonderful to see — that their interactions with each other were becoming a part of their experience of writing and of themselves.

Or poems can be written to and about people, relationships, and interactions in the world. In *Rust or Go Missing*, I was thinking through ideas about speech and how words from another can serve as comfort, or alternatively, how speech can be a means of trying to box a person in, as the poem "Transference" acknowledges with "I've let you box my insides." That line is directed to our culture, in a way, and to the sometimes limited range of possibilities we might see put forth for "acceptable" kinds of relationships and identities.

Accompaniment can be revelatory and transcendent, but it can also bring us to dark places in our lives. Acknowledging the complexity of how we are in relation to other people in the world can, I think, enlarge the aperture of our experience.

Sreshta Rit Premnath, *A Cage Went in Search of a Bird*

Sreshta Rit Premnath: By engaging with forms of interrogation and representation, this work explores how otherness is constituted through complex matrices of knowledge, power, subjugation, and mediation.

Debra Di Blasi: Somewhere on the briny deck's a boy yanking cable or rope and licking his lips bitter of nights pretending the dead never mattered. Only the redblack blood round his thumbnail says otherwise. Though it's his bleeding what's left of memory. Were the sun hot were the sun seamed he'd shake it all off smudge it with the back of his hand across his brow and let the blood be to dry and flake. Only then too he thinks what happened wouldn't because because *see that spot of teal where's their blood sank in absence of us neverbeens sometimes scratch a spot on my cheek that blushes or bleeds but there'll be no scabs or scars* oh the idea's the revelation's soon gone sloshed and slipped over the deck or in the stoop of a sailor smoking squinting hard at what's not there to feel the pleasure of his vice. That's it, he thinks, what remembering's got to: a vice a vice that lets the cable or rope slide burnless through his hands and what little's started's already left of his life so that he says aloud at the wake a knife's edge: The stars are washing toward us and we've not been here long enough to disappear.

Somewhere on the briny deck's a boy yanking cable or rope and licking his lips bitter of nights pretending the dead never mattered. Only the redblack blood round his thumbnail says otherwise. Though it's his bleeding what's left of memory. Were the sun hot, were the sun seamed he'd shake it all off smudge it with the back of his hand across his brow and let the blood be to dry and flake. Only then too he thinks what happened wouldn't because because, oh, the idea's the revelation's soon gone sloshed and slipped over the deck or in the stoop of a sailor smoking squinting hard at what's not there to feel the pleasure of his vice. That's it, he thinks, what remembering's got to: a vice a vice that lets the cable or rope slide burnless through his hands and what little's started's already left of his life so that he says aloud at the wake a knife's edge: The stars are washing toward us and we've not been here long enough to disappear

Complexity

HLH: These poems [in *Vocabulary of Silence*] repeatedly note the distinctions we impose between the voiced and the voiceless, the named and the nameless. Are those clues to the meaning of the interest the poems take in silence? Is it a premise of the poems, first signaled by the book's title, that poetry is a form of attention to the *vocabulary* of those who are not permitted a *voice*?

Veronica Golos: I'd begin by thanking you for your questions. The book arose, almost physically out of me, because of the desert of silence around the continued U.S. wars in Iraq and Afghanistan, and the deafening silence around the continued removal and dislocation of Palestinians. These silences might be likened to a rag stuffed in a mouth.

A central image for me, at the heart of the book, was the photo taken at Abu Ghraib of Private Lynndie England holding a leash attached to the neck of a bound and naked prisoner, nicknamed "Gus" by the U.S. soldiers. The photo was taken by Corporal Charles Graner, England's superior officer and lover.

Among other things, I was stung by the lack of a name of this prisoner. Who questioned this "un-naming?" Doesn't naming bring us closer to that which is named? Poets may disagree on this, but I do think that a being's name begins our narratives about the life lived *within* that name. Not an Iraqi, but *Mohammad, Omar, Jawad, Ali, Selma, Madia, Fatima, Suhad, Hussein, Ahmed …* as I list them in the title poem of the book.

When performing "News of the Nameless," and the original version of "Photo/syn/thesis" — both poems that ask, "What is his name?" — I make the phrase a chant, repeated over and over and over, in the manner of some of Tracie Morris' early work. I changed the poems for the page because I felt the question worked better stated "quietly," as it were. It became more effective. This is an area of considerable interest to me: the way our poems can work differently on the page and on the stage.

One of the things I ask of poetry is a way to see through to "the other side." In one of the Veil poems ("Sixth Veil)" in *Vocabulary of Silence*, I write: "Don't Assume / There is a divide. Who speaks? Who listens?" That is, reality changes, or magnifies, or pivots with who it is that speaks, who it is that listens.

This division is simple, and yet, I believe, crucial. I don't imagine that my views on life, art, poetry, politics, and so forth are universal ones. I don't imagine that others see me as I see myself.

Poets reveal themselves and their thinking not only through their skill, craft, and deftness of word, but also their position in the world. There are sides, and it's vital to take them. I am drawn to poetry that reveals paradox; that insists on contradiction and complexity, yet is able to do so in an accessible way, in the manner of Komunyakaa, Darwish, Weigl, or Rich, among others.

I attempted to meld history and the personal, to combine the political and the psychological in *Vocabulary of Silence*. I spent a good year reading translations of Arab poets, both Arab Americans and internationally. How they blended in their social awareness into image and form, but used poetic forms. I think of craft always. Craft, and the use of forms which can push a poet into unexpected places. For *Vocabulary of Silence* I used the Ghazel, as shown by Agha Shahid Ali in *Ravishing Disunities* — along with The Bop, chant, fragment.

Which leads me, again, to the silence in your question. In my book, my poetic stance is one of being a witness-from-afar to the wars conducted in my name, as well as to war in general. It is a peculiar position in many ways. Unlike, for instance, Brian Turner, or the great European poets of war, I am not there — I am here, seemingly safe, seemingly afar. My poetic stance is a kind of leaning forward, as if my feet are encased in cement, as I lean toward Iraq, Afghanistan, Palestine, the countries, yes, and their poets. Silence is a place of linkage in a poem, a place of entering in, I think. Visually and sonically. Yusef Komenyakaa says: "I think where the abstraction exists is actually in that space between images. And that space helps to create tension in a work of art. In writing or music this space often equals silence. I suppose, what we're really talking about here is a way of thinking and seeing, a way of dreaming and embracing possibility."

In addition, I tried in *Vocabulary of Silence* to point whatever fingers there are to point, to myself. In the poem "Samaria," the last line is: "I am the core through which the bullet fires."

Because I wanted an accounting. An accounting of my own silence.

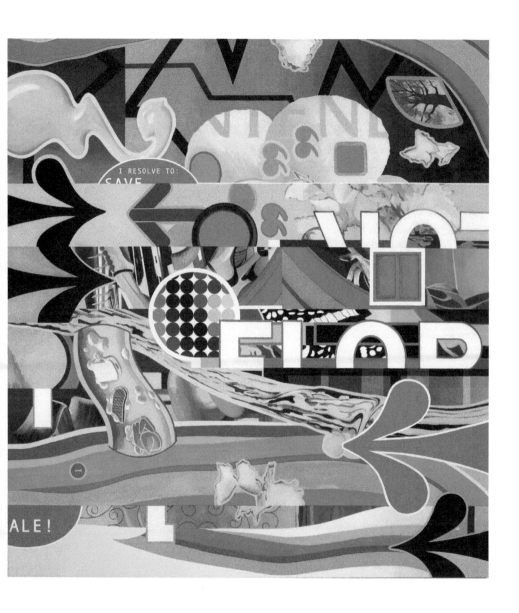

Alisa Henriquez, *Resolve*

Alisa Henriquez: My recent paintings source mediated images, graphics, and texts found in popular culture. Through the act of cutting, re-assembling, and painting a multitude of samples and fragments, I aim to re-animate the messages these media images perpetuate. Conceptually, the paintings aspire toward a similar density as the compositions hold, locating themselves somewhere between the critique and the embrace, the humorous and the ponderous, and the colloquial and the formal. In using such a layered approach, I hope to create works that move at an oblique angle to the overly simplistic identity constructions that are found in many media images that I source.

Caleb Klaces

"An abundance"

Daisy, who grew up in the countryside,
 hates golf courses. Their terrified
 neatness, she wrote, ends
 history. So it seemed justice done
when a fairway, smooth as plastic wrap
 over a full landfill, turned slowly
 gray-brown then
 collapsed, to reveal
a pit of rusting signs and goo. Unlike Daisy,
 I have played golf and known,
 as the hole finally takes the ball,
 the pleasure of having got a future
right. The pleasure, too,
 of catching in motion the ways
 the land lies. By the time
 it arrived, Daisy had told me
everything in her letter
 except the letter, the envelope,
 the satisfying grubbiness

of transit between then

and now. It felt like a stranger

coming home, uncanny

and actual.

Here in Texas it is Spring,

if you can imagine. Hornets

are explaining perspective

from the head of a nail.

Inside the cells

stuff is born that won't live:

some of it complicated,

wrapped in wings;

some sludgy brown pap.

Unfinished life

and *waste*

fall either side

of today's brief

purpose. I hope there is something

in this letter

not overtaken by events.

Many thanks for the tree,

I will keep it as it is

in its bag.

Opposition

HLH: Very early on, the book [*Apart*] speaks of "words that trouble simple oppositions, words like discourse, ideology, blood, race, family, nation, history" (p. 12). Then those words recur, woven throughout the book, troubling simple oppositions. Just to cite one example: "Race was the way of enforcing power relations and at the same time a way of disguising it" (pp. 102–3). You say, soon after that race passage just quoted, "I don't want to be a cynic" (p. 103). But is the book cynical? Does it doubt the possibility of really troubling the simple oppositions? Or is it hopeful, insisting on the possibility of troubling the oppositions? Or have I just proposed a simple opposition that ought to be troubled?

Catherine Taylor: Well, yes, I guess you have set up exactly the kind of opposition that I try to "trouble" in the book. But I don't mean to say that you shouldn't do that, or that an either/or way of understanding the world is wrong-headed. It is, I think, inevitable, or at least habitual, for us. This is precisely one of the issues I wanted to explore in *Apart*. You ask whether the book is cynical or hopeful about the possibility of troubling the simple oppositions. If you are asking whether or not I think these oppositions can be troubled, in other words, can one accomplish a meaningful dialectical mode of inquiry? Then, yes, I am not just "hopeful" about this, but dedicated to that possibility. But I think there are at least two other questions lurking here.

The first is: Am I cynical or hopeful about whether this rhetorical strategy can have any impact on the reductive binary habits of cultures at large? Or to put this another way: Can dialectical writing in a marginal work like mine (or any other) encourage us to consistently trouble the crude oppositions we encounter in public discourse? The second lurking question is: Am I cynical or hopeful about whether this strategy can have any impact on the *content* of those oppositions? For instance, can dialectical writing have an impact on racism or class struggle? My knee-jerk response is that I'm hopeful about the first and a bit more cynical about the second. But then, I have to ask myself why do I bother, if all I hope to change are habits of thought, not habits of action.

And I'd have to ask myself about the necessary relationship between habits of thought and habits of action.

Ultimately, I'm not under the illusion that my book is going to change the world, but I do feel some obligation to write in a way that is consistent with the kind of thinking and action that I hope to see in the world. Writing isn't action, but writing isn't not action, either.

Now you have me thinking about George Oppen saying, "it seems always impossible to prove that it [art] is going to be valuable, and yet it is always quite clear that the art of the past has been of value to humanity. I offer it only as a suggestion that art lacks in political action, not action. One does what he is most moved to do."

Jane Lackey, *golden maze, west*

Jane Lackey: My work explores forces that draw people together into temporary networks of activity and inter-relationship or consequence. In previous works, I have looked to our internal bio-systems to understand how we are different and what we have in common. Mostly we are the same, yet small differences create complex variation. Our cells function through systems of fluid affinities and alignments. Synapses bridge the gaps. Throughout it all, there is constant formation bringing success, failure, opposition, adaptation, and change.

Looking at phenomena outside of us, similar characteristics are at work as we link and engage socially. Many forms of discussion and conversation both virtual and *in situ* move between us invisibly forming a glue of short-lived connections. Mapping this ambiguous and effervescent space requires the ability to lock and unlock relationships. Consequently my tools of drawing are tape, stickers, dots, labels, and stitches of thread that are easily adhered or released as they mark direction, interaction and place. Thin coats of paint mask or reveal the delicate translucency of paper as a network of shapes is formed throughout.

In the fall of 2007, monks, nuns, and activist in Burma (Myanmar) undertook a surprising protest, marching through specific public sites along the streets of Rangoon. A human chain of bystanders supported this quick and coordinated uprising against militaristic sanctions related to fuel prices. Images circulated around the world. In just a few days' time, news of this clash was suppressed by the military and media access to its aftermath dissolved into thin air. My *golden maze* series maps the potential space of this march and its unknown system of coordination. I imagine how connections were made in suppressed circumstances involving secrecy, perhaps a code of communication within a mazelike structure. My audiences can engage and delve into intimate passages while developing their own narratives of space, time, and force.

Carol Moldaw: I puzzle over this maze, as if over a soluble enigma. On the computer screen, the yellowing scotch tape has a burnished beauty, the sticker cul-de-sacs and the temples outlined with dot labels an austere geometric serenity. Ley lines and dream-time are brought to mind. The stitching reminds me of chromosomal structures, in a vague way, to match the vagueness of my knowledge. I take in the information on the artist's statement as if it were written on a transparency, an overlay, that I can peer through or lift at will, like an architect's drawing of a room with or without furniture. With or without people, history. Not that I now "see" thousands, tens of thousands, of monks or the chain of thousands of laypeople protecting them as they marched, but now I know they were there, that this is their "potential space"; their "unknown system of coordination," to be imagined, imagined here. Then I read a little more, elsewhere, and when I go back to the golden maze I must square the serenity I first perceived with the image of police beating their shields with batons, of monks wearing gas masks, and fire trucks filled with pesticide spray. "Synapses bridge the gaps." I think about the implication of politics being, at their core, not simply partisan, but "particle." In my nerve endings I feel how the quiet has changed from calm to deadly. In the stitched noncontinguous routes I now see something like Ariadne's thread, which allowed Theseus to go all the way in, not without fear but without hopelessness. The temples are not whited-out, they are un-touched-up, their dotted outlines the monks' fuel.

Each Begun with a Stain

↦ THE OPPOSITIONS FAMILIAR FROM PHILOSOPHY — appearance vs.
reality, presence vs. absence, and so on — are familiar because we face them
continuously. They pervade our experience and structure our lives, defining
the problematics in which we are enmeshed. If things may *look* one way but
be another, then accurately distinguishing between the two (and consistently
maintaining the distinction) will ward off, as *failure* to make and maintain
the distinction will invite, deception and illusion. If things and persons may
be present to us or absent from us, then my presence will depend on, and be
constituted by, what is present to me. I will be present to all that is present to
me, and absent from all that is absent from me.

The participants in this exchange remain alert to such distinctions and prob-
lematics, and to their consequences. So Jacqueline Jones LaMon sees the
tragedy of *overlooking* those who are missing: of mistaking their *absence* for
unreality. She posits a connection across losses: if we overlook those who are
missing, then "parts of ourselves 'go missing.'" Murat Germen recognizes that
to ignore the ordinary is to acquiesce to "imposed institutional realities," to
submit to how others have made things *appear*, rather than recognizing how
things *are* in themselves. Valerie Martínez and Katherine Tzu-Lan Mann

both emphasize that presence is sustained by *connection*: the person to whom I am not connected is "other" to me, and her absence from me is absence in my own identity. In being absent to her, I am absent from myself. If for Martínez connections between persons are the reality of persons, for Mann the connections between things are the reality of things.

These recognitions impose ideals and ambitions on the work of the artists and writers here, leading LaMon to listen for "the portions of our histories that remain unknown to us, and the stories that remain hidden and untold," Laurie Saurborn Young to allow "the small pieces that are often overlooked" to "drift forward to be recognized," and China Marks to "relinquish control and to remain open" to what "I would otherwise not have access to."

Because the tree in Nina Foxx's meditation has been present to much, the story it whispers is rich and edifying. But its story is whispered only "to those who might listen." Among whom might be counted the participants in this exchange, who speak to what they *hear*, and hear what they *listen to*.

Voices

HLH: Near the end of "Preface" (p. 11) [in *Last Seen*], you speak of the children's "collective voice" as what you strain to hear. Yet the poems themselves seem especially attentive to *individual* voices. What for you is the relationship between individual voices and collective voices, in these poems and in relation to the children?

Jacqueline Jones LaMon: First of all, thank you so very much for taking the time to read the collection with such attention and care. And thank you for your question. *Last Seen* was inspired by the hundreds of long-term missing African American children who have historically been overlooked by our national media. It is a collection that evolved in focus and definition, from being a collection *about* those missing children to being a broader exploration of what it means to be missing or lost in our society and how that void is experienced by all those who remain present and connected to each other.

I still strain to hear that collective voice of what the missing and lost could have contributed to our existence. I still wonder what the excised portions of our selves could produce in this world, if only allowed the space and opportunity to do so. Sometimes, we censure ourselves for self-preservation, or other seemingly rational reasons. If we do this enough, parts of ourselves "go missing" and all of us experience the aftermath of this disconnection.

I made a decision to not try to replicate the voices of the missing children. All of the persona poems in the collection are from the perspective of some other voice in the world of the missing: the parents or other relatives, the officers working on the case, the suicide jumper who is depicted as the person to last see a missing child, a seagull … The voices that one hears in this collection — the individual voices — are there to emphasize the great void that one does not — the collective missing, the portions of our histories that remain unknown to us, and the stories that remain hidden and untold.

Murat Germen, *Truth Is Stranger Than Fiction*

Murat Germen: Photography is an opportunity for me to find things people ignore and bring them forward to make people reconsider their ideas. I am not interested in extraordinary things since they are always covered and receive more attention due to mankind's unending interest in celebrities, fame, sensation ... I try to concentrate more on ordinary things and catch possible latent extraordinariness in regularity. It is easy to take ordinary photos of extraordinary things but more challenging to take extraordinary photos of ordinary things. It is possible to say I tend to concentrate on extracting some peculiarity out of the ordinary. I attempt to defamiliarize ordinariness, render it ambiguous by alienating it from its familiar context, and finally make people to "see it afresh."

Photography records the surface information, where one can only depict the exterior features of objects (color, texture, shape, etc.) and the resulting visual representation cannot incorporate the internal condition / content / soul. I also aim to make photos that carry the many traces of time, multiple dimensions of space, and finally create photos usually invisible to the naked eye. The basic idea is to form a personal visual accumulation through time and space that supposedly gives us more insight / clues than a single photograph. I see multilayered photography / chronophotography as gates to augmented perception, surreal encounters, creation of new worlds, and self appropriation; since I do not believe in ultimate objectivity in photography and "Truth" with the capital T. Personal delineations of temporary yet experienced smaller realities are truer than imposed institutional "realities." The key is reflecting the inner world with a genuine, idiosyncratic way: "Do not follow the suggested agenda / trend, do your own thing ..."

Nina Foxx

"If Trees Could Talk"

One day I looked at this piece, and I saw naked people in the trees. I didn't understand it.

A second day I looked at this piece, I saw naked people in the broccoli. I didn't understand it.

A third day, I walked my dog and sat under the old tree that leans to the side, overlooking the coast outside my door. Suddenly, as I sat there, I remembered the day before, when instead of sitting on the grass, I sat in the weathered Adirondack chair placed here by the residents.

Last week, I stood under the tree and watched my daughter climb the exposed and gnarled roots of the tree.

Suddenly, it made sense to me. The image isn't about naked people in trees, instead it speaks of the history of the things that take place under the tree, the silent memories that people leave behind.

If trees could talk, we'd see what had been done there in the shadow of the leaves. We'd hear whispers of the words that had been spoken, and read their transcripts in the tree rings.

There was a huge cherry tree in the yard where I grew up. It was so massive, it spread over almost the entire property, or so it seemed, even provided some shade for the neighbors. I've lived my life under that tree, leaving my own images of my memories.

When I was four, I picked up the cherries from the ground in the shade of that tree, and stared at my red stained fingers. I wasn't quite sure that they were cherries then, asking my mother if they were poison berries and if I were going to die from eating them.

When I was six I'd climbed that tree, almost to the top, actually, just to see into my neighbor's yard, so high, that the branches complained under my six-year-old weight and my father was scared gray.

When I was ten I played hide and seek behind the trunk of that tree that was wider than I was and rough like sandpaper.

My brother hid my diary from me at the base of the tree and I couldn't find it for days. When I did, I cried out in joy, even though the book had been ruined by rain. That was right before the house behind us exploded in a burst of flame after the neighbors tampered with the gas meter. The smoke from the cherry tree filled our house and drove us outside in the middle of the night. Although the leaves on the neighbor's side of the fence withered and crumbled to ash, the tree didn't burn down.

It was still there, presiding over the funeral of the little girl that lived in that house, three days later.

She'd refused to jump from the second-floor window into the arms of her parents and perished in the fire, but the tree stayed behind to whisper her story to those who might listen.

If trees could talk.

Particulate

HLH: "A Perpetuall Light" (p. 57) [in *Carnavoria*] includes the declaration "How particulate our lives." Your choice of "particulate" rather than "particular" makes this declaration seem important to the book's focus. On the one hand, there is a repeated tendency to consume the particles of our particulate lives, to be carnivorous, and on the other there is a tendency to collect the particles, to catalog and list them (p. 23), to sequence them (p. 33), to "take stock" (p. 72). Am I right to see this sense that our lives are *particulate* as one thematic concern in the collection?

Laurie Saurborn Young: Harvey, thanks for asking this question. As it happens, particles have been much on my mind, lately, as I've taken a layperson's interest in quantum mechanics. To put the theory *way* too simply, all we see before us — our family and friends, children, pets, tables, windows, clouds, roads, oil — are made of atoms oscillating at different energy levels. Everything's buzzing; everything is moving, even when it appears to be at rest. In turn, atoms are a type of particle, which brings us to that wonderful word, *particulate*. There's the use of *particulate* as an adjective, relating to separate, minute particles; as a noun, as in a *particulate substance*; and then also there's *particulate inheritance*, a.k.a. Mendelian Inheritance, which has to do with how characteristics are transmitted by genes. In a way, our lives are unavoidably particulate.

In writing a poem, I suppose I am always moving toward those Intersections of particles and perception. Toward a conglomeration of sound, science, music, and psychology. Our neurons, our brains, are made of particles. What are thoughts made of? The words on the page are constructed of particles, but what of the words in our heads? Our voices? Some sort of particle not yet discovered? It's strange to think of particles as indicative of connection — we tend to use the word in terms of finite limits — but by sharing the characteristic of a *particle nature*, if you will, then doesn't this point to the connectivity of everything and every creature? Perhaps we are particulates within the Great

Particular? In current times we are overly concerned with — and convinced of — our body boundaries. That's one of the bigger failures of consciousness, in that it excuses a lot mistreatment of others, be they animal (I'm including humans here) or plant or mineral or water. I read a lot of Whitman last year, and to me he is the Supreme Quantum Poet: *For every atom belonging to me as good belongs to you*. We are big believers in *or*. As in I am this *or* that. *Or* causes such stress, such isolation and sadness! There's a real relief in believing in *and*: I am this *and* that. So in more direct reference to your question, in the poems the actions and themes of digesting, collecting, cataloging, and taking stock all co-occur.

This happens within books and within lives. I hate to bring in this over-used reference (though maybe it's not over-used in poetry — yet) of the movie, *The Matrix* — the scene where Neo and Trinity are dodging bullets in slow motion, and flipping upside down in those sweeping leather jackets. There are times in our lives — ones of great happiness, sadness, and courage — when one's experience of the world is slowed down, and certain particles from that background (the building lobby) come to the foreground (whizzing bullets). A major destruction of the fourth wall. In living, we are not projected; we are not acting. Somehow, we are apart and within at the same time. Ultimately, I guess I'm writing toward that *and*, toward that suspension of movement. Of getting to a place, by one's own choice, or not, where time and space slow down and certain small pieces that are often overlooked drift forward to be recognized.

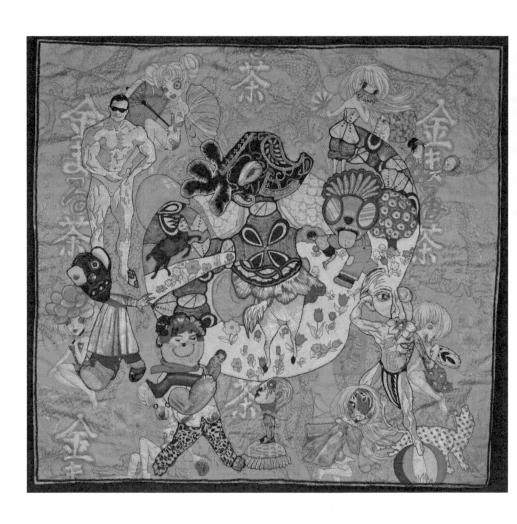

China Marks, *Drink Me!* (2005)

China Marks: I use an industrial sewing machine, thread, and imagery appropriated from printed fabric to make process-directed contemporary drawings and books. Process is the transformative agent, synthesizing and subverting the forms and stories contained in the original sources. Since November of 2010, I have been working on a series of drawings that incorporate text that I write myself as well as imagery. In 2013 I acquired a computerized embroidery machine and CAD software in order to generate embroidered text.

Denise Duhamel

"The Year of the Muscle Man"

I open my fortune and there he is:

a stud wearing only slight sky blue briefs

extending his hand. My friend hears me gasp and cracks

her cookie too. A hunk in a green and black

loincloth steps out. Their bodies are like those

drawn by Henry Gray. Sinew anew, bicep flex, movie star calf.

This is the Year of the Muscle Man,

our waitress tells us. We are pink and exaggerated,

corseted, with wild hair. We are no longer young

but still sprout wings and yellow wigs, panther prints

and paisley scarves. *I had forgotten all about men,*

I say, what with wallpapering my apartment

and my unsettling lavender dreams. My friend

had been busy too, planting her tulips, cleaning out

the bauble heads and stuffed animals

her kids left behind in the garage.

We order another round of umbrella drinks,

our muscle men straddling our long straws,

our labia filigreed with gold.

Connections

HLH: The list is a very powerful form of communication, if a context for it is already present. So the Vietnam Veterans Memorial in Washington, DC, is a powerful monument in part because most of its visitors arrive with prior knowledge of what is being memorialized. If 450 American girls and women had been murdered in a twenty-year span in two cities on the U.S. side of the border, surely everyone in the United States would know about it, but because the tragedy addressed by *Each and Her* takes place on the Mexico side of the border, very few U.S. residents are aware of it. Is there any sense in which one might say that the other poems are there to prepare the reader to receive the simple lists of names in parts 32, 44, and 61?

Valerie Martínez: With a book-length poem like *Each and Her*, the lists and the "contextual poems" (prose and facts, quotes from theologians and horticulturists among others, lyric fragments, diary entries, dreams, and more) work in circularities. Or at least they are meant to. These circles are "drawn" by the various threads that evoke a range of connections between the United States and Mexico — the Rio Grande, the drug trade (for which Americans are highly culpable because we are its largest consumers), domestic and other violence against women (there and here), personal/familial experiences on both sides of the border, the business of NAFTA (U.S.-owned maquiladora factories along the border), etc. At the same time, the poem evokes larger circles and connections — the cultivation of roses and the rose as a symbol of femininity, women in works of art and photography, the body (in most cases female) as a locus for human dignity and compassion, the politics of "free trade agreements."

The lists in parts 32, 44, and 61 directly follow parts which emphasize (respectively) a history of Greek and Roman women and their remarkable accomplishments, the flower/rose metaphor at work in the poem, and the Virgin Mary of Guadalupe who is revered almost feverishly in Mexico. In this way, the lists are meant to emphasize enormous loss as well as the hypocrisy of our

"reverence" for women, including mothers of gods. At the same time, the lists are meant to "stop time" in the poem, particularly the three-page list of all the murdered Marias. The lists are incantations — both terrible and reverent. I hope they dissolve any sense of *this country* apart from *that*, *me* apart from *she*, *us* apart from *them*, and urge the reader to sit in a difficult and beautiful place of connection. We have names (and lives and thoughts and feelings) exactly as do our sisters and daughters and aunts and grandmothers and wives exactly as do the women of Juárez.

Without a sense of connection to the women of Juárez, they will simply become "others" or, worse, objects.

This may be much more of an answer than you bargained for but this book, for me, is as much a love poem as it is a terrible rendering of what is happening in Juárez. Love is about deep connection. Above all, connection is what *Each and Her* is about.

Katherine Tzu-Lan Mann, *Maw*

Katherine Tzu-Lan Mann: My paintings show how patterned, highly wrought, decorative elements coalesce from the chaos and contingency of an organic environment — and how they dissolve into that environment again. I begin each painting with a stain of color, the product of chance evaporation of ink and water from the paper as it lies on the floor of the studio. From this shape, I nourish the landscape of each painting, coaxing from this organic foundation the development of diverse, decorative forms: braids of hair, details from Beijing opera costuming, lattice-work, sequined patterns. Although founded in adornment, these elements are repeated until they too appear organic, even cancerous ... and they at once highlight and suffocate the underlying ink-stained foundation. Each of my paintings is tense with the threat of disunity and incoherence as nature and artifice spring from and merge into one another, and as different elements multiply and expand like poisonous growths.

My paintings are utter hybrids; man-sized fields punctuated by moments of absurdity, poetry, mutation, growth, and decay that I find both suffocating and fabulous. They glory in the sensuous and the rambling, but intersperse the chaos with moments of neurotic control. They explore the potentialities of growth, but also of overabundance. I think of my work as baroque abstract: a celebration of the abundance of connections and clashes that can be found in the disparate mess of matter in the world.

Anis Shivani

The owl in his viscous habit is a vicious interlocutor.

There is no scarcity of noiseless interlocutors on the planet of cats.

The shape of a cat's smile is an inward twist ruing well-meant praise.

Anger survives like a forgotten connection from the age of bronze.

So according to the demoniac formula,

last night we infiltrated Eden's paltry bazaar,

where the holy man dismissed the kimono and the saree and the abaya.

I undressed myself in front of ornamental eyes.

In winter save your caul of a head from bitchy accountancy.

They want to measure you as part of the trinity of cat and owl and corpse.

They want to strand you in the blueprint of an orgasmic dress

stretched over you like wind in a field of wheat.

There is no fourth stanza.

The depressive monologue sifts its callused feet amid million-dollar screenplays.

Every war has its subsequent neorealist period,

the vanguard standing pat in its own bucket of blood.

Alive in a Strange Region

↦ THE POET SUSAN STEWART asserts that listening "has a moral economy." Some features of that moral economy are implicit in the familiar formulation "He's a good listener": that one may be better or worse at listening; that listening well is relatively rare; that one's way of listening (and whether one listens well or poorly) participates in establishing one's identity; that the quality of the listening that occurs within it influences the quality and durability of an interpersonal relationship (at any scale, from a couple in love to nations in conflict); that listening is an *attitude* and a *project* and a *decision* and *action*.

Here, Kristi Maxwell states explicitly what I take as implicit in the others' statements: that each is engaged in, or engaged *toward*, "a poetics of listening," the orientation of the moral economy of listening toward what Maxwell, citing Donna Haraway, calls "an ethics of response — a response-ability." The writers and artists here enact that "response-ability" variously. Aviva Rahmani makes her work performative and collaborative; Rupert Loydell (or at least the first-person speaker in his poem) wonders and wonders; Jill Magi accedes to vulnerability; and so on.

What the listeners here listen *to* varies. Aviva Rahmani listens to dreams and to degraded coastal landscapes; Jill Magi listens to "the very specific language of museum and memorial design"; Brian Dupont listens to the plays of Samuel Beckett and to "common signage"; Jena Osman listens to etymology; and so on. Regardless of what each primarily listens *to*, though, he or she listens *for* one another, for an *us*. Each listens responsibly and responsively.

Listening *matters*, which is why the health of a democracy depends utterly on its securing and maintaining freedom of speech. Freedom of speech is not a *liberty*, a luxury of activity to be maintained primarily for the sake of the individual, but a possibility condition for democracy itself, without which the collective cannot *be* a collective. Freedom of speech only accidentally preserves one's ability to speak; essentially, it preserves the conditions for the possibility of our hearing one another.

Response

HLH: At some point during my reading of your book [*Re-*], the phrase "stream-of-sonority" came into my head, by analogy with (and contrast to) "stream-of-consciousness." It seemed to me that the poems *listen* to language, adapting consciousness to it instead of adapting language to consciousness. (Or something like that; surely I'm not saying this well.) So, with that in mind, when I get to the sentence on p. 45, "Language a device that keeps wonder at bay," I wonder if for you that listening, letting sound determine the course of the poem, is a way of letting wonder overwhelm.

Kristi Maxwell: Harvey, first of all, let me say thank you for such an attentive reading of *Re-*. When I was writing these poems, I often thought about a poetics of listening. In many ways, these poems are an attempt to respond to language through listening and being faithful (and unfaithful) to listening while transcribing; by unfaithful, I mean: one ultimately makes choices about what one hears, so one denies at the same time one accepts. This denial makes absolute fidelity impossible — I heard more than I actually transcribed, and I collaborated — I brought desire in, and it infected/affected my hearing and seeing. Listening so often happens with the eyes rather than the ears when it comes to writing. Recently, I took part in a weekend of writing collaborations, and a Dragon was used to translate speaking into writing in a word document projected on a wall. The system tended to translate background noise as "you and him you and him you and him." A couple. A doubling. No one was saying "you and him" until the technology brought it to the room, or we were all saying "you and him," but didn't hear it until the technology pointed it out to us because it wasn't what we had *intended* to be saying. I don't know what we might have been saying in other languages. I imagine we could have asked the Dragon to tell us. Though a generic "he" and "she" live in the poems in *Re-*, the primary relationship being explored is that between the/a writer (both myself and not, I think) and language. Over the past few years, I've been more and less obsessed with feminist philosopher Donna Haraway's *When Species Meet*, which thinks about bodies in relation to each other and an ethics of response — a response-ability (to use her term). I am a body,

language is bodies, writing is bodies, I am bodies, and we are all inside and outside of one another. Intersecting and resisting intersecting or not yet in a space where we can enter each other's spaces. One of *Re-*'s re-'s is *re*sponsiveness, which often entails "letting sound determine the course of the poem" and "adapting consciousness to [language] instead of adapting language to consciousness" all the time, as you so wonderfully suggested. I do think you said that well. Thank you for saying it that way. The line you're referring to in the fourth section is: "Logic a device that keeps wonder at bay." In my experience, logic can often quell proliferation, whereas wonder seems bound to proliferation — to possibility. "Both/and" rather than "either/or." I aim to be one who wonders — who experiences wonder. I like that poems seem to contain wonder in the form of questions. The writing that keeps me gives questions rather than answers. Gives and gives. Reading Nathalie Stephens' *Touch to Affliction* gave me the words to articulate the question "what can I do to prepare to receive language?" I'm glad it seems you put yourself in a position to receive something from *Re-*. Thank you for giving me this space for thinking about some of the things you received.

Aviva Rahmani, *Lane's 1*

Aviva Rahmani: My ideas evolved from activist performance work in the sixties, feminist art practice, and an interest in city planning from a young age. Dreams, intuitive and ritualized strategies are part of my methodology.

Publicly, I have always worked performatively and in collaboration, often with scientists. My presentational means have ranged from found sound mixed with bel canto singing, virtual and digital technologies to painted murals of geomorphic relationships. Stand-alone painting is a very personal form for me. It is where I have always privately worked out my theoretical grounding.

The basis of my ecological art work, including the recent project, *Gulf to Gulf*, is grounded in a theory I have developed of Trigger Point environmental triage. Trigger Point theory means applying traditional aesthetic tools for the analysis of small, carefully chosen areas of degraded coastal landscape to leverage large landscape healing. I call that "good housekeeping" for the earth.

Rupert Loydell

"Trigger Point Blue"

Sorry about this but I was wondering, I was wondering if it's good weather out there. I am struggling to find good weather, struggling to catch the horizon line, manipulate the heart response, catch the horizon line, manipulate the heart response.

I was passing by. As I was passing by (self-sustaining hyper-irritative focus) I felt okay (self-sustaining hyper-irritative focus). I feel okay in the morning although my eyes are plastered in the morning, plastered over so they cannot see. Sorry. It's about over so they cannot see. But I was wondering.

Stay tuned for more to evolve. I believe the phenomenon occurs followed by heart response. The exact same phenomenon occurs followed by (common name) local twitch response. The color caught my eye, my name, my heart response, local twitch response. The color caught my eye, a tiny contraction of knots helping people understand the physical pain in their lives, the physical pain in their lives. Twitch response. Trigger point.

Superficially, all the experienced players play. Look at the dry needling, look at how big the gap is. Stay back, this garden is a bodywork, a twitch response, a multimedia book and new technique. A twitch response, a

multimedia book and CD ROM. Here is a blue tree in an original design, the result of tiny contraction knots helping people understand. Not bad.

There's nothing more to reference. Still, there's more including diagrams, including diagrams and symptoms it is fiercely unwilling to give up. This little guy gave up. This little guy is back in the back garden. We can travel between palpable nodules in taut bands of muscle empowering people. Taut bands of muscle empowering people take care of themselves. You can self-treat, you can self-treat your own pain without drugs. Not bad: your own pain without heart response.

Sorry about this but I was wondering. I was passing by and I was wondering. It's about over but I was wondering. The color caught my eye as I was passing by but I was wondering. Sorry for no heart response but I was wondering. I was passing by and I was wondering.

Language

HLH: I become interested — how could a reader not? — in the apostrophes or short letters to various objects ("Dear Theater:" "Dear Tower of Hope:," etc.) at pp. 33, 43, 45, 56 [*SLOT*], and so on. What is the role of these letters (?) in the work, and what do they invite from the reader in regard, for instance, to point of view? (And how do they relate to the series of letters beginning "Dear J.,"?)

Jill Magi:

Dear Harvey,

Thank you for this inquiry. First, I want to say I am not sure about the why of many things in *SLOT.*

But I remember, while composing its pages during a residency with the Lower Manhattan Cultural Council — so I was downtown quite a bit — wanting to say something to someone, almost anyone, about the events of September 11. And I wanted to say something as a New Yorker deeply affected by that day. I was interested in Paul Connerton's proposal in *How Societies Remember* that memory is incorporated — taken in to the body — and official textual and/or landscaped representations from the state usually cannot capture these incorporations. Also, if certain events are not written or landscaped, it doesn't mean they have been forgotten.

How to transfer Connerton's thesis to writing this book? That was my initial question.

I was wary of saying things that were definitive, official in tone, able-to-be-politicized. So I came up with "Dear J." it seems, as a device to try and reach across silence between friends, even, and silence within my own self. I was shocked by how much we did *not* talk about that day in the years that

followed. There are many reasons for this, I think, including the ideological conundrum of being anti-war. For example, when I tried to speak about that day, folks would often respond with "But what we're doing in Iraq is wrong" and though I agreed with them, I felt silenced. To some extent, out of shame for our government's global actions, I think we self-censored and did not tell our September 11 stories very much. The apostrophes in *SLOT* alert the reader, perhaps, that this is not an overt political texture, or to politicize a personal correspondence would be their choice.

So the "J." is me, at times, and also J. happens to be the first initial of several of my good friends, the first initial of the name of my beloved, and my mother's first initial, and so through this writing, I ritualistically (like invoking someone's name in prayer or meditation) brought all these people near me. This invites, I hope, the reader to imagine discourses that are unofficial, that might be sent in private letters, or conversations that might happen around dinner tables.

But I think it's important to remember that I did not sit down and ask, "How should I write this?"

SLOT came out of a many-years process of stopping and starting, and any time I felt I was getting too fluent in its premises — in the theoretical part of the research — I probably turned to apostrophe in order to check my sense of honesty. Was I saying what I really wanted to say? Here I want to note that I usually do *not* care about "honesty" in writing and never try to judge this in another poet's work. I am quite fine with inauthentic voices, taking on personas, and so on. But for this project, I needed that sense of address in order to make sure I was still being personal about my research.

You ask about "the apostrophes ... to various objects." I imagine that my "Dear J." instinct seeped over toward architecture.

The body being pressed upon by ideology landscaped — this is what I hope *SLOT* enacts: a body presses back.

How, after September 11, did I feel in my body riding the subway? Answer: I got panic attacks. Several of my good friends developed these also. So we developed whole new breathing mechanisms for survival. Answer: I dedicated myself to poetry, which meant tuning in to these phenomena of meaning, language, experience, and turning away from a rather dead-end administrative job and toward financial sacrifice. Answer: everything I knew about architecture and violence changed. I saw myself inside of buildings, in tunnels, in elevators, being blown up. Where would my shoes go? How scattered would my body be? Would I be identified? I saw and dreamt of fire everywhere; I touched the body of my beloved in a new, perhaps more tentative way; I watched him turn the corner of our apartment building hallway nearly every morning, waiting until he was out of sight before closing the door. Tracking his trace — all of our mortality — our possible last touches.

Through poetry or poetic inquiry (so the form could be sentences or something that looked like an essay and sometimes poetry — genre was of no concern), I decided I could pay attention to this — not dwell on it, but write through it. Or I would have probably gone insane.

When I encountered the very specific ideological language of museum and memorial design in my research — a poet colleague turned me on to this storehouse of language available on various museum-design firm websites — I did not want to just take the language and use it ironically. I felt that I should take the language of these structures and designs into my inner circle, if I could. I wanted to approach their goals with some amount of respect. Using the found text only might turn those completely understandable memorializing efforts into pure critique.

As a person who found poetry after studying social science, I am keenly aware of this:

A body who stands in front of something only to critique is a tense and electric body. I know this body — I am this body many times, and often when I feel afraid. What if I could envision my body standing in front of a memorial, a

museum, the designers' plans for the memorial, addressing the structure, the document as a "Dear," with some softness, even if I might see right through to its limitations, follies?

I needed to write *SLOT* in order to feel these things in a body that would, with vulnerability, take many realities into its tissues — including the urge to memorialize and the urge to forget. What if everything, including built structures, is impermanent *and* is the Beloved? Perhaps the language of apostrophe brings us closer to that compelling but difficult to conceptualize "what if."

All my best,
Jill

Brian Dupont, *Catastrophe*

Brian Dupont: I focus on the visual possibilities inherent in language; I take the written (or printed) word as source material, stressing and distorting the text through the painting process. In my recent work I have begun to experiment with painting as a three-dimensional object. Working in oil on aluminum I engage with the techniques of high art and common signage so that the painted surface and language are placed on equal footing. *Catastrophe* takes its structure from the 18-inch-tall black box in Beckett's play of the same name; the source text is the list of on-stage characters, with the three characters appearing on stage each occupying a facet of the exterior box, with the offstage technician rendered on the support's interior.

Rita Wong

"detritus "

catastrophic world records—biggest landfill, largest nuclear meltdown, most voracious corporation, most toxic tailings pond, most brutal massacre, hottest year, most rapid species extinction—collapse of easter island, vikings died out on greenland while the inuit survived, global economy's specter—choose your direction/devotion carefully

trophic cascade, phytoplankton, unraveling circuit boards, algae, jellyfish, crows, cockroaches, viruses, bacteria, endocrine disrupters, acid rain, technicians of the inadvertent, old rags, rascals, spools of tape, dusty boxes, the dark nurse, grains, husks and shatter, how quietly this night releases our cumulative monuments to ourselves

Words

HLH: In *Lyric Philosophy*, Jan Zwicky proposes, "Few words are capsized on the surface of language, subject to every redefining breeze. Most, though they have drifted, are nonetheless anchored, their meanings holding out for centuries against the sweep of rationalist desire." Her focus there seems to be on language's *contrast* with history, the way words hold their own in spite of history. But as I read your etymological inquiries in *The Network*, your focus there is on a *parallel* relationship between etymology and history: words as historical archives, reference not only as designation of a present object but also of a historical continuum. How far off base am I in that reading?

Jena Osman: Really interesting question. I don't think I'm trying to argue that words are completely flexible, bending entirely to the historical moment. As Zwicky says, meanings drift but are still anchored. But I don't believe those meanings exist out of context — there isn't some kind of platonic ideal of words lurking out there outside of their use. Words are the product of their usage, and I'm interested in trying to map out those uses. As I say in the book, if I could follow the history of the words I'm looking at, maybe I could understand the history of the times. But I'm not a linguist, so this is more of a fantasy than a reality. The word maps I trace in *The Network* are thoroughly amateur, the product of my trying to "translate" the entries I found in a book by Eric Partridge called *Origins: A Short Etymological Dictionary of Modern English*.

My interest in connected etymology and history was sparked by the work of two poets who have been really important to me: Cecilia Vicuña and Tina Darragh. I quote from Vicuña in the first poem of *The Network*: "To enter words in order to see." This is from her book *Palabrarmás* (translated by Eliot Weinberger and Suzanne Jill Levine in the criminally out-of-print *Unraveling Words & the Weaving of Water*), which begins "The original book *Palabrarmás* was born from a vision in which individual words opened to reveal their inner associations, allowing ancient and newborn metaphors to come to light." She

goes on to make the power of etymology explicit ("A history of words would be a history of being …") through her own verse lines and an extended mix of quotations from Ernest Fenollosa, Heraclitus, Heidegger, and others. In that book, there were moments like this:

> Truth, in English, is derived from the Indo-European root *deru*, to be firm, solid, steadfast. Suffixed form variant *drew-o*, in Germanic *trewan*, in Old English *treow*, tree.

And these moments were clearly in the back of my mind as I sat down for the first time with Eric Partridge's dictionary.

In 1993, Leave Books published a chapbook by Tina Darragh called *adv. fans—the 1968 series*. This book is very rare, almost impossible to find, but thankfully Craig Dworkin has posted it on his incredibly useful small press poetry archive, Eclipse. In this piece etymology is read as the record of a specific historical moment. Visual collages made from folded-over dictionary pages are sandwiched above and below by definitions of words that came into existence in 1968. Of this work Darragh has said that she was trying "to investigate what went wrong with language in 1968. I remembered the dissolution of alternative living arrangements and businesses as beginning with words — the failure of political projects as being partly a language problem." And so this book, too, was in my mind as I worked the etymological charts in *The Network*.

Words might not capsize, but they drift and sometimes swerve (to use Joan Retallack's word). They're subject to play, to reinvention — and poetry is the form that can most call attention to that flexibility.

P.S.: I recently came across a project called "Mysteries of Vernacular" which is a collection of animated videos that tell the stories of particular words — ultimately there will be one for each letter of the alphabet. Although it borders on the precious, I think the animations do a good job of capturing the narrative drift of a word's journey from origin to present use.

Sarah Walko, *"We explained we breathe through glaciers, 400,000-year-old ice. Each contains eighteen tales of bedrock and extinct lakes, some form of cloud duration and eight flowers."*

Sarah Walko: If this work fails to take a straight course, it is because it lives in a strange region. There is no map. No table of contents. It walks and works until it is worn away. This work might be a book, with tiny worlds and words fluctuating between micro and macro to simply say, You are no where else right now but here and this is the invention of questions.

> Memory, like the mind and time, is unimaginable without physical dimensions. To imagine it as a physical place is to make it into a landscape in which its contents are located, and what has location can be approached. If memory is imagined as a place — a theatre, a library — then the act of remembering is imagined as a physical act; as walking. To walk the same route again can mean to think the same thoughts again, as though thoughts and ideas were fixed objects in a landscape and one need only know how to travel through. Walking is reading, even when both are imaginary and the landscape of memory becomes a text as stable as a garden, a labyrinth, or stations.

> — Rebecca Solnit

Bin Ramke

"Mattering"

out of gloom uncoiling

yet the lines are straight in a locally Euclidean sort of way

the shape of a kite compels geometry

the measure of the earth the earth of measurement

being still so far for so available a being

still in broken and disguised patterns

o so broken we have become

we always were so, broken, becoming

a beautiful a blue a sky blue sky

remember watery sky blushing

into dark continuous twilight two lights

are better than none uncoiling a

kite straight string

out of gloom uncoiling a gorgeous need

I like lines rulers ruling the paper

the point of o perspective if you like

like if you speculate a point of

departure order a point of blue in

the kite shaped sky through windows

windowing a world winnow a world

I am wondering how wide a lake a

single cloud might make,

how blue a shape

Under a stagnant sky,

Gloom out of gloom uncoiling into gloom,

The River, jaded and forlorn,

Welters and wanders wearily — wretchedly — on

... that wastes this floating, transitory world ...

William Ernest Henley 1849–1902

Darkness creates spaces ...

Ascension is achieved below the horizon line ...

she wrote, digging

her way out of the blue air into

I knew the mind of a boy as a place but disorderly but minded his manners his matter he was blue and seemed to have a shape like a soap film within intersecting sticks as if any polygon could think imagine he was more beautiful than ice you had to be there there was weather in there, and moons, too, and a prim cloud of primes, twins alone.

To Invent a Method

↦ THIS BOOK is structured by grouping: it is a *composition* (our English word from the Latin prefix and root meaning "put together"); it is a *synthesis* (our English word from the Greek prefix and root meaning "put together"). I hope that each grouping foregrounds certain associations between the elements within that group, but the fact that a reader might discern, or create, associations *across* groupings reveals how rich the works and statements here are, and how much larger the composition is than its compositor.

Here, for instance, it would be hard, I think, to read Sue Sinclair's description of "the path to responsibility" (namely, "staying tuned into the world around you such that you become intimate with its mysteriousness, know it as both familiar and other") and not associate it with Kristi Maxwell's affirmation, above, of "response-ability." Similarly, one might associate the tree in Jonathan Weinert's piece here, in which he and his friends hid, "ready for any miracle, silent inside the tree," with the tree in Nina Foxx's piece, behind which in childhood she played hide-and-seek. Or again, though images made from cut paper may not seem at first glance much like images from a re-purposed scanner, one might associate Anne Devaney's invention of a method suited to her ambition with Bruce Checefsky's invention of a method suited to his.

Which is not to say that nothing characterizes this grouping as distinct from the others. In fact, they seem to me associated by a shared reflectiveness about what Dan Beachy-Quick calls "those myths that mark for us the origins of our own imaginations," as when Kathleen Wakefield associates the rhythm and imagery of her *Snaketown* with her Mormon childhood, in which "I saw, early, things I didn't like — beauty with snakes in trees." Of the writers and artists in this group, I would want to describe theirs as an instructive attunement to what (in Wakefield's words) "makes you stand up and watch."

Beauty

HLH: I didn't read the biographical information about you until after I'd finished the book [*Snaketown*], but it didn't surprise me to learn of your successful career as a lyricist: the whole novella has a quality I would call "lyrical." One aspect of that quality is that each section seems not only connected to the other sections but also complete in itself, able to stand on its own as if it were a self-contained prose poem. (This would be true of any section, though such sections as 6 and 44 seem especially vivid examples.) But you're not obliged to share *my* conception of the lyrical, or my sense of its value! What, for you, is the importance of lyricality as a quality or characteristic of fiction?

Kathleen Wakefield: The first word that came to me in answer to your question about the importance of lyricality as a quality or characteristic of fiction was "rhythm." Being an actual lyricist, it's always been about the rhythm — the saying of a few words in a limited amount of time — words that sing, have cadence, and are full of emotion. In songwriting, you have three and one half minutes to break a heart, impart a message, make a statement — beginning, middle, and end — more is too much. I started writing fiction to free myself of the three-and-one-half-minute limit. My first published fiction was half a page long — I couldn't do more, and I wasn't sure I could ever get beyond that. I did, but carried rhythm and less-is-more with me — and maybe the essential beauty of heartbreak.

In writing, rhythm travels — takes you over mountains, hurries, lingers. It looks up and down, notices stars, tells you how much time you have to get to where you are going, what's behind, what's ahead. Cormac McCarthy has a rhythm like footsteps, running, horses galloping — like gasping for breath. I feel the rhythm in his every sentence and paragraph; feel it in Hemingway's bravado, and beauty framed by death, feel it in writers who write about boxing, evoking dance steps, poetry, paragraph-rounds, and defeat in slow motion — Eddie Muller, Leonard Gardner, F.X. Toole.

Lyricism, in writing, to me, makes you stand up and watch, take a step, move away in fear, run alongside like a camera on a dolly — watching every scene, feeling every feeling — close enough to hear the breath, see the perspiration, what the character is thinking — witness close-up, the hesitation, the stumble, the fall, death, and resurrection. Lyricism — "emotions in a beautiful way" — captures the beauty in the heartbreak — lets us know it too is there. Jim Crace can write about a deceased couple on a beach, but take you through the tall willowy and enchanting grass full of living, thriving things, to get there. Tim Winton — Australian — in one of his stories, possibly "That Eye The Sky," finds a man alone, hopeless, devastated — on an island — but as I remember, finds something, wire or string, to turn a tree into a guitar so that the wind can play music to him.

In *Snaketown*, although the subject is horrifying — a kidnapped child — the landscape is breathtaking — calm and extraordinarily beautiful and full of blue skies. There are sweet but forlorn echoes of old music, old guitars, memories, Mexican love songs. Still, there are snakes in trees, bats from old buildings, tarantulas crossing the road, coyote traps, rotting meat, and something is — terribly wrong. And, of all things — evil finds a home — or a place to spend the night.

I was raised Mormon within the most loving and wonderful of families, but possibly because — as I might in any church or religion — I saw, early, things I didn't like — beauty with snakes in trees. In church there was so much mention of "the devil" that I wondered what and where that presence was — it seemed illusive, feared, and so much more interesting. Was it in the dirt, the walls of our house, was it there for all of us to see, who was it and where did it abide? In *Snaketown*, in my own way, in examining the walls, the dirt, the echoes, the hills, the things crossing the road, or crouching on the eaves of barns, or on Orin's, shoulder, I found a voice, literally — and lyrically — for that presence, and possibly, without being aware of it, and not yet completely overcoming my predisposition for time restraint, allowed each chapter to tell its own story, perform its own three-and-one-half-minute heartbreaker.

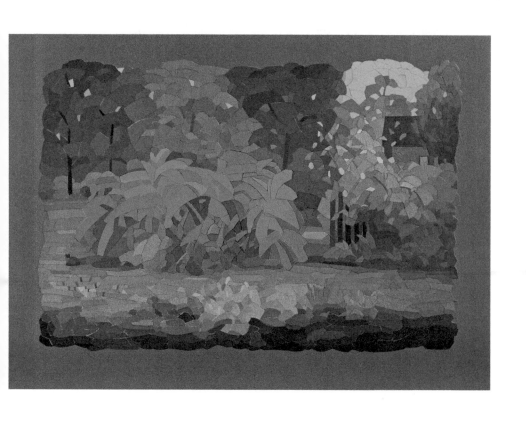

Anne Devaney, *Late Summer*

Anne Devaney: Broadly speaking, nature is my subject. I'm trying to create a visual equivalent for the look of the world and my experience of it. While doing that I also hope to create a beautiful object that is intriguing and even fun to look at.

The "cut paper" method evidenced in this show evolved over a long period of time and was shaped by many influences, among them: a primary concern with precise color, a keen interest in textiles and mosaics, artists too numerous to mention, and a desire to capture imagery that was often transitory. Subjects that are available for only a few days at best, and often for only a few minutes, require an "indirect" method. The reality of my life also did not allow for hours of uninterrupted studio time. Thus, a method that was broken down into various phases was essential. In *Preparation for Painting* (Oxford University Press, 1954), a wonderful little book full of good advice, both practical and wise, Lynton Lamb writes, "The artist invents for himself the skill he needs." An important part of one's skill is a method, which also needs to be invented, a method that is consistent with one's goals and one's life.

Jonathan Weinert: As a happy child who had an unhappy childhood, I needed to invent a method, by means of which I could construct a series of more or less coherent images, out of small colored fragments, to represent a life. My canvas was the campus of a private girls' high school in a posh New England suburb. My father taught there, so I had the run of the place. Rich abandoned houses overhung by ancient beech and maple trees, manicured fields deserted in the finest weather, permission to ramble at will beyond the reach of the other troubling neighborhood kids — these encouraged my taste for depopulated landscapes, for disappearance shading into disembodiment. My family lived with no visible daily connection to our working-class mongrel–Baltic Jewish roots, nor were we under obligations to the old-money hyper-Protestant social order which surrounded and ignored us. I was unclaimed: gloriously and disastrously free.

I remember a small ornamental tree, the name of which I never knew, whose vinelike leaf-covered branches grew out of the top of the trunk and hung down like hair, brushing and in some cases growing back into the ground. You could get inside and sit with your back against the trunk, seeing out without being seen. One summer midnight I took a handful of friends with me into the tree. We were long-haired Pre-Raphaelitish freaks, a few years too young for the killings and the protests and the draft. Nothing touched us. We were bright-eyed and ready for any miracle, silent inside the tree, until Andy blew a few notes on his flute. We watched as stars clocked slowly over the green-black leaves.

Aura

HLH: I am struck by the ambiguity of the book's very last poem, "Asleep" [in *Breaker*], especially its last line. "We sleep side-by-side with eternity, and never touch" might mean that we two humans (the speaker and the particular person being addressed by the speaker) sleep, both of us alongside eternity, and we two humans never touch one another, or it might mean that we humans each of us individually sleeps alongside eternity, and we never touch eternity. (The line might sustain other meanings as well.) No doubt the ambiguity is intentional, so I do *not* ask you to "settle the matter" by removing the ambiguity, but I *do* ask: How does the line's ambiguity cast back over the poems that preceded it in the book? Does it magnify other ambiguities?

Sue Sinclair: The line does seem to raise the question you've unearthed: who or what exactly is sleeping and not touching? In some ways the answer depends on how one reads "we," but it also hinges on "eternity" — what exactly *is* it? I think that this particular dimension of the line's ambiguity may be important: in some ways eternity has to be ambiguous, undefinable — it's more than anyone can say. At best we might say that eternity is the mysterious, massive something of which we are all a part. So insofar as I'm part of it, I'm intimate with it (sleep side-by-side with it). And insofar as you're a part of it and I'm sleeping side-by-side with you, I'm intimate with it. But there's still that way in which it's out of reach. It's both part of my everyday life and utterly ephemeral. It's both me and beyond me.

Although I can't say what eternity is exactly, I can say that the feelings it gives me are ... not quite ambiguous, but complex, paradoxical. I'm comforted by the felt presence of something so massive to which I belong in my every waking and sleeping moment; it's a kind of home. But it also makes me feel lonely, because I can't quite touch it (what *is* it?) and I don't always know it's there — who lives her life in constant awareness of eternity? Even when I am conscious of it, it's so large that it can be hard to feel at home in.

Here's another way of thinking about the ambiguity around eternity: are you familiar with Benjamin's use of the term "aura"? He tells us that he means by this "the phenomenon of a distance no matter how close" (among other things). In some ways the line from "Asleep" is about this phenomenon.

I've gone on about the ambiguity of the word "eternity" and my complex feelings about it because you asked about the relation of this line's ambiguity to ambiguities in the rest of the book. To be honest, I don't think of my work as presenting many ambiguities. I do use a lot of "we" but I tend to think the referents are usually pretty clear (though I could be deluded!). But I explore this phenomenon of closeness-in-the-midst-of-distance and distance-in-the-midst-of-closeness again and again (and again). I've always loved the idea of developing a familiarity with what is mysterious, of limning the contours of mystery. I guess that's what I think of a poem as doing. And it also seems to me to be part of the task of living well in the world: staying tuned into the world around you such that you become intimate with its mysteriousness, know it as both familiar and other. This, I think, is the path to responsibility.

Anna Von Mertens, *The Duke and Duchess of Urbino's auras, after Piero della Francesca*

Anna Von Mertens: Odd avenues of knowledge and inquiry interest me. I research further and uncover phenomena in isolated fields of study that mirror information about my own private world. I then translate this empirical data into a subjective version to reflect the parallels I see.

I have tracked how energy is dispersed in a nuclear explosion and how energy is stored in a cell; exposed hidden topographies (of the human body, of the ocean floor); contrasted migration routes of birds to the migration routes of humans; and shown the stars exactly as seen above violent moments in American history.

These patterns reveal to me aspects of our existence, whether it is how we experience time and face the infinite — embedded in that is our own mortality — or how the boundary of the body is presented to others versus how it is felt internally.

I use the stitch to follow these trails, tracing the paths with my fingers. The dotted line of hand-stitching is a marker of uncertainty, a way of exploring. The time invested in making the work, allowing for contemplation and internalizing, becomes a part of how the work is viewed.

I see all of these elements as a form of mapping, reflecting the need to get my own bearings in this vast universe.

Afaa Michael Weaver

"Coordinates and Interstices"

In the absence of narratives, spaces open onto nothing,
the population of that which is yet to be made manifest —

> exciting the field:
> her chair slid forward
> something scraped the ear
> a perfect spider formed
> shadows fell against rain

no doppelgangers, no joints recollecting
memory, smoothened fingers without
prints, feet above the snow, no prints,
noses against the window, no steam,
no evidence of decisions to undo beauty.

> possible universes:
> the cyclotron saw it all
> once connected, the collected
> mind of imagination called itself
> cyberspace, snowballs, cotton candy &

things form above the definite evidence

of life encircling the back of the head —

the Internet

— conclusions and possible conditions include:

1) the electric/nuclear formation of mind

2) retreating to the first simple facts of mind

3) breath ending, surrendering to mind

4) worlds inside the lapsing of mind

5) noses giving the immediate "no" to mind

6) eyes supporting cases against a mind

the end of life will be Mind As Nation ... as

"I" exposes itself to claim the dry and bright,

seeing, holding its arms to take in the two ends

of the landscape of what came to be without "I"

so that "I" is dependent on and absent from

wishes and dreams.

Space

HLH: In the Emerson passage from which the book's title [*Circle's Apprentice*] derives, and which you place as an epigraph, Emerson seems willing to conflate a spatial sense of circle with a temporal sense: the limitless size of the circle ("around every circle another can be drawn") and the unendingness of the circle ("every end is a beginning"). Both of those *seem to me* to be in play in the book: e.g., "horizon for a coast" (p. 4) as one example of the "spatial circle," and "one syllable / Extended without breath / To infinite duration. Voiceless / Voice, sphere's edge" (p. 18) as one example of the "temporal circle." *Are* they both in play?

Dan Beachy-Quick: I do think — or is it that "I hope" — that both elements of the circle are in play: temporal and spatial. I suppose I think about the circularity of the book's concern in a number of ways. At a formal/spatial level, I sometimes think of any given poem as a bounded thing, and the lines of the poem are a kind of investigation as to the nature of their own limits — as if the poem is written so as to discover its horizon, its limits, which can be discovered in no other way than by writing the poem. Part of the beauty of a book is that each subsequent poem breaks the boundary the previous poem realized — or at least, so seem the books I love, and the books I would most want to write. I also think about the poem as a timeless space — one we can experience only by the terrible paradox of needing to do so in time. Syntax at some level promises time is involved in the work of reading, and so even as we dwell inside what we read, we are also always ushered out of the space — Arcadia with a metronome, the hand pointing from origin to exit, over and over again, as the music fills the space between. This also feels like a universal plight to me, and this plight was much on my mind over the years I wrote *Circle's Apprentice* (the same years in which I began raising my children, a geometric realization of life's circularity, too, and an introduction to time that I could not have expected before having a child). I suppose I keep feeling that poetry mimics other forms of exploration, astronomy, for instance, in which the rupturing of one circle is not only the destruction of a defining center, and so an opening into bewilderment, but also is a motion into time, into origins.

As one travels outward, and ages as one does so, one also becomes witness to origins that undermine the sense that our life's temporality presses upon us most as a linear structure. At the outermost edge of the outermost circle, where astronomers search for that background noise that is the big bang's excessive remnant, I can also imagine those myths that mark for us the origin of our own imaginations. We expand so as to return — to find, impossibly enough, the single point where logic teaches us we should find the widest arc. I guess I feel poetry is deeply indebted to these kinds of circular impossibilities, both spatial and temporal, and continually discovers, as does astronomy, that the two are intimately, inevitably, related, if not one entirely.

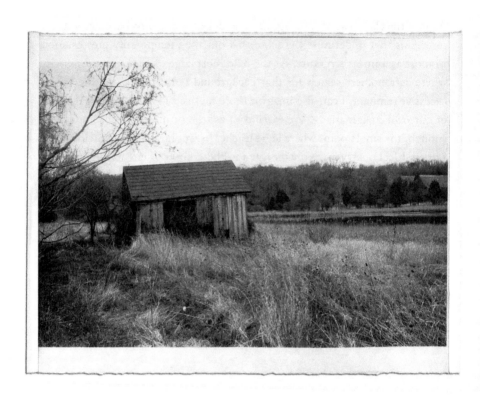

Cassandra Hooper, *Landscape (Wild Turkey)*

Cassandra Hooper: *Wild Turkey* is a large-scale artists' book from my current series: *Playground*. It reflects my interest in how the tug-of-war between personal identity and public persona is revealed. I am drawn to human gestures that signal a breech in artifice, to attention-seeking relics that symbolize the conflict and to irreverent spaces where one might imagine another chapter in the standoff. Seeking (but not always finding) the possibility for balance, protection, safety, or glory at the intersection, this bookwork references the potential of the inside/outside juxtaposition. Conceptual dichotomies are mirrored by the literal pairing of images, sandwiching of photographs, and by an indiscernible mixing of old and new technologies for making that is characteristic of my particular brand of printmaking.

Alyson Hagy

"Wild Turkey (Landscape)"

Bonita says, You don't got a good reason to go by that house, ever.

Uncle Harman says two of his sisters could call in a turkey as good as any man. One sister, she was the girl what flew an airplane during the war when they run out of pilots. It was in the paper when she died.

My grandma saved all of Granddaddy's tools. Every one of them. They're mostly in the barn now, moldering in a corner with the old horse harness. Every now and again Carson, he's my youngest, he goes down there and takes one, that's if he's fixing a table leg or whatnot.

Bonita says, They hung a man at that crossroads. Everybody knows the whole ugly story. Long time ago, but people around here they don't forget.

Granddaddy was a farmer all his life. His mama was a Altice from the Glades. Her family didn't have nothing. That's what she always said. Nothing. I never knew a man who hated tobacco more than Granddaddy, but that never kept him from planting it or us from having to work that hot field every summer.

Forest Kemp'll give you good money for barn siding. I heard him say so after church last week. Good money, the worse them crooked boards look, the better. I swear Old Man Gerry Prillaman must be rolling in his grave. He loved to burn a building of an evening, especially a cow barn. Only man I ever knew who'd smoke a store-bought cigar in the company of his wife.

The old scratch callers work best, the ones that got a piece of hard slate where you can make that *erky-erk-erk-erk* sound. Just like a hen coming out of the piney woods with her ugly head held high. A tom gobbler goes for that. *Erky-erk-erk-erk.*

Bonita says, This family ain't got a thing to hide. There won't be no discussion of that bank mess. Unh, uh. But you can come in here and look around all you want.

This and Other Labor-Intensive Techniques

↦ EVEN SUCH UNREFLECTIVE USES of the word "real" as the old slang imperative to "Get real" and the old advertising slogan that "It's the real thing" imply that our relationship to reality is not given, not transparent or simple, not imbued automatically or necessarily with authenticity. Some *people* are more "real" than others, and if I want to be real I will have to *get* that way. I might live in such a way that I make myself real, or in such a way that I *fail* to do so. Similarly, some *things* are more real than other things, and I will do well to attend to and align myself with the more real things in preference to the less real.

The conversants in this section are *reflective* about our relationship to reality. In this regard, Laura Mullen's meditation is representative. Prompted by Adriane Herman's memorialized ephemera, Mullen reflects on the importance of looking attentively at "constructed and abandoned realities." We are taught *not* to look at certain spaces (such as those we name "by-products," "collateral damage," and "garbage"), and certain spaces (such as oil-producing areas) are made hard to look at. Against those forms of denial, Mullen insists that "we cannot find our way to any truth without accounting for those (objects, landscapes, others) we've insisted are (or rendered) invisible."

Similarly, Lisa Fishman, meditating on her book *Flower Cart* as "an inquiry into what is most real," is drawn to consider "the multiplicities of the real and its logic of alternativity," and to make a play on the word "sidereal," moving away from its dictionary definition to "think of side-real, something being real (or being perceived as real) to the side of itself," as if to fulfill Dickinson's injunction to "Tell all the Truth but tell it slant."

That both Mullen and Fishman appeal explicitly to Wallace Stevens, a poet whose entire work is dedicated to pursuit of "a new knowledge of reality," prepares the reader for Jennifer Atkinson's quiet allusion to Stevens, her ending her poem (and this section) with the words "distant glitter," appropriated from Stevens' poem "The Snow Man," which seeks, as the writers and artists in this section seek, to behold a reality replete with "Nothing that is not there and the nothing that is."

Attention

HLH: Yeats proposes in "Adam's Curse" that apparent ease in poetry results from heavy labor. Your poems, to me, have the sort of ease he speaks of, but I wonder if there are clues in your work [*Unbeknownst*] itself that the ease comes from something else: I am thinking, for instance, of the "guiltless and forthright response" offered by the streetlight in "Instead" (p. 11). The response is *offered*, as a result of *noticing*, so I wonder if you would agree with Yeats, or if you would attribute the apparent ease in the poems to attention instead of to labor. (Or indeed to something else: you're not obliged by the false dilemma I just formulated!)

Julie Hanson: I believe there has been long preparation somewhere even with the poem that comes "as a gift" — the poem that feels, even to the writer, as if it has arrived nearly intact. *Unbeknownst* contains within its pages a sampling of the full range, from "gift" poems to poems that were years and years in production and rest, production and rest, and if those in particular can "seem a moment's thought," I'll be most pleased. Either way, quick or slow to arrive, there has been practice. The long labor on some bad poems that never do satisfy me and never do get published may well account for the very little labor on some that I like right off the bat. I think of ballet dancers at the barre, or any athlete doing the repeated exercises to build the strength and dexterity needed to perform the movements that will seem effortless. And so, whether the lines in a particular poem have suffered long hours of "stitching and unstitching" or not, if the poem seems effortless in the end, I would say there's good likelihood that there have been hours logged in in the practice. But would I call that activity "labor"? Especially "heavy labor"?

No, not really. I'd call it a pleasure. It always feels good to have written something, because, exactly as you have suggested in your question, poetry is a noticing. Composing is an act of attention. And as a re-examination of an earlier draft, the revision portion of the writing is also a kind of noticing. And with it, there enters into the picture the noticing of things unnoticed in the first act of attention. I produce a draft, or even a mere fragment, but it

seems worthless and I set it aside. When I come back to it later — and this happens to me all the time — I find to my surprise that there is something there, something interesting enough to engage me. How is it that the value of the first attempt has been upped? The difference is not in the words. It's in the context. Time has marched on and other things have entered my consciousness. Since the time that chunk of writing was produced I went to the grocery store and overheard a conversation, saw various common wildlife in the yard, and cooked dinner with my spouse. I fell asleep after rereading a section of *The Half-Finished Heaven.* I woke up and read the newspaper. I had forty-five more memories and made seventy low-level judgments and decisions. So now when I come back to the thing I wrote down yesterday, other things suggest themselves as possible companions to, or extensions of, that scrap of thought. Furthermore, today's rhythms are sufficiently different that it is easy now to notice the rhythms and mannerisms of the previous writing. Yesterday those features may have felt like part of my thinking. Today I can hear them as separate from my thinking. I can recognize them for what they are at one level of remove and in so doing I might take note of their compatibility or discord with the subject at hand. [In fact I may — only now — identify the subject at hand!] As for the now-recognizable features, I may decide I hate them or I may decide I love them. I can use them or leave them behind. I can perfect them, or disturb them. Whereas yesterday I could only produce them.

I suppose it's at this point where the writer may feel most conscious of seeking, or hoping for, that effect you have spoken of, "apparent ease." This is also a probable point, I suppose, for losing it!

And, actually, even with the poem that seems to arrive all of a piece, a similar process may well be underway during the original session, since, even in a first draft, words are crossed out, carets inserted, intention is realized, and a direction is discovered or altered along the way. Case in point: I was reminded recently of how much the details I select may factor strongly in determining the purpose of a piece when, during the Q&A at the close of a reading, someone asked me if poems like "Always a Little Something Somewhere in the Purse" (p. 25) are put down pretty much as they happened to me in the incident reported, or if they were, more often than not, composites. [An above-

average question, I thought. Examples of each are certainly to be found in *Unbeknownst*, and it is interesting to consider what makes the writer take one course — probably quite unconsciously — over another.] In responding, I said that the poem mentioned happened to be of the first sort, and it was then that I recalled the impetus for the poem, which, as you might imagine, was the story the poem withholds, the story the distressed woman in the airport had told me. But the poem never shares the slightest detail of the story. When I began to write this poem, I fully intended that I would be re-telling at least a part of her story, but once I came to the line "Then she told me everything" I knew I was done. Her story would never be told. The poem was about something else.

I was lucky that day to be paying attention to the draft, paying attention to the writing itself. On another day I might have held ferociously to my original intent, and had I done so I'd probably still be trying to end the poem properly.

Adriane Herman, *A Good Cry*

Adriane Herman: I trace the seemingly alchemical trajectory from intention to action by studying and re-presenting other people's "to do" lists. In both form and content, these humble documents of other people's efforts to get things done move me to collect and re-present them in ways that might yield fresh regard. I utilize labor-intensive processes to highlight humble yet remarkable specimens from my archive of found, gifted, and bartered lists. Communing with the ephemeral residue of human commitments, tastes, priorities, accomplishments, and procrastinations allows me to mine the extraordinary by sifting through the purportedly ordinary. Hand-written lists seem on the precipice of extinction, yet there is much we can learn from such intimate yet anonymous evidence of how others choose to spend their most precious resources of time, energy, and attention. I welcome mailed donations of obsolete lists, which can be addressed simply: 04104-0011. My current focus is lists that are entirely or nearly all crossed out such as the source list for this etching entitled "A Good Cry," which bears items lyrically crossed out except for the word "tissues."

Laura Mullen: It's an honor to be asked to respond to this artist: by guiding our gaze to ephemera we tend to ignore, Adriane Herman does for the list what Duchamp did for the urinal and bottle-drying rack. The "Dump" — as Wallace Stevens reminds us — is the proper location for serious artistic inquiry: we need to look at the ("the"!) constructed and abandoned realities carefully. In her work, Herman enacts a certain transparency (the "artist" disappears), becoming the glass through which we see the world differently, and she takes us over the jealously guarded line between art and life. I see her exploring "borderlands" (in Gloria Anzaldua's sense) and place her work in conversation with that of contemporary artists whose subjects are memory and identity (I think of Christian Boltanski), as well as feminist artists who take on the problem of work ("women's work") that is not meant to last (the image of the artist Janine Antoni mopping / painting the gallery floor with her hair comes to mind). It is more and more clear that, if we are to survive (politically, physically, spiritually) we must expand our gaze beyond its current margins: "byproducts," "collateral damage," and "garbage" are some names for areas under denial, spaces we are taught not to look at, not to weigh. But it is precisely those spaces, left out of our calculations, which shape the spaces that we agree matter, and we cannot find our way to any truth without accounting for those (objects, landscapes, others) we've insisted are (or rendered) invisible. Because of Herman's work, I picked up and held onto the grocery list (written on a paper plate) I found blown up against one of my tires in the vast parking lot of a Target superstore; in the franchised, impersonal spaces of America, fragile traces of the individual are resonant treasures, essential to our understanding of humanity and community. These monumentalized lists are powerful evocations of embodied presences (the "hand") and time (the crossing out and discarding of what seemed urgently necessary information …) as well as the unreliability of memory and the brief ferocity of will. And of course these *clues* give us vivid images of other lives: "So everyone's a poet," as Gertrude Stein put it, or perhaps I should also say, "so everyone's a detective," which is a pairing — since she admired the genre — Stein might have liked: reading, at this level, *is* writing. I would call these lists (found) poems — which is part of the reason I have chosen to respond in prose, and with some images inspired by Herman's work.

Harvey's query regarding his project reached me at Wood's Hole, where I had gone to interview a scientist referred to as "the oil spill guru." I was starting a sabbatical dedicated to the completion of a hybrid text playing with the Romance genre, but I had spent the summer trying to understand the environmental catastrophe in the Gulf of Mexico, attempting to clock both the representations of the event, and the problems in the response — problems that seemed tied to failures of vision. (Oil-producing areas are evidently, and this is true globally, places it seems difficult to look at directly or to focus on effectively.) The work I had been doing, and the presentation of this particular opportunity, took me into a joking / not joking space, in which the complications of desire became my subject: the first two lists felt transgressive (even abject) in different directions and, like the last one, also seemed both sad and silly in a way that pleased me … (Who hasn't said to themselves, "Breathe!" Who hasn't, if they thought about it, been grateful that that is not something we have to think about?) These images (or "exposures") of lists are thank-you notes to the artist whose work and the poet whose kindness invited me.

~~Breathe~~
~~Take another breath~~
~~Breathe through my nose~~
~~Breathe~~
~~Inhale~~
~~Exhale~~
~~Inhale~~
~~Exhale~~
~~Breathe~~
Keep breathing

To Do!

~~NEA~~
Guggenheim
MacArthur

To Do?!

~~Fall in love~~

~~Date~~

~~Fall in love~~

Marry

Have Children

Divorce

Confrontation

HLH: With lines such as "It is absolutely unnecessary to write serious poetry" (p. 5) and "Poem that erases itself as it is written" (p. 52) appearing periodically through this work [*Mother Was a Tragic Girl*], I wonder: are these poems, for you, essentially tragic (like the mother of the title) or essentially ironic? (Or, of course, essentially something else, or not susceptible to any characterization of essence …)

Sandra Simonds: So, I think that this dialectic between sincerity and irony is very complicated and it's one that many of us confront through language. Both irony and sincerity are intimately connected with desire since irony and sincerity are the superficial manifestations of those desires. I'm not thinking about desire as purely "personal" desire but also collective desires, revolutionary desires, desires for new ways of seeing the world, desires for social transformation. But desire itself is a kind of swamp full of surprises. Sometimes we want what we want, but often, we don't *really* want what we want. Sometimes we act on what we think we want only to have our fantasies thrown back in our faces and we see just how rigid is the social order and the ordering of our interiority. On a daily basis, we must pretend to desire things that we don't actually desire and the ultimate horror would be actually getting those desires fulfilled since we don't really desire them. This, in some sense, is what one would call the maintenance of a social order; Žižek talks about this.

But poetry should be a break with the social order. We are as skeptical of irony in a poem as we are of sincerity because we somehow sense that these tools are inadequate reflections of our desires, yet they are still the tools with which many of us work, however limiting. If done well, irony connects itself to the negative, to wit, to intelligence, to humor particularly by exposing hypocrisy. I think that perhaps many people mistakenly confuse irony with cynicism. I think of Laura Riding when she says "anarchism is not enough" or Žižek says that that we can only learn desire through our fantasies; this sometimes takes the form of a confrontation. In the first line of my book a husband tells

his wife, "It is absolutely unnecessary to write serious poetry" and this is a confrontation — between two people (a man and a woman), between opposing ideas about poetry (serious or foolish), between the absurd and the "real."

Too many poets are caught up in the happiness and feel-good silliness of their own social circles, in "liking" everything. I don't want to like everything and everyone because, frankly, I don't. I want to believe in things that are real and so do my poems. I want to like things because I *really* like them. But the only way to do this is through what Marx would call a ruthless critique.

In response to the husband's statement, I would say that whatever the language-shape or manifestation of a poem (sincere, ironic, conceptual, lyric, or something else) all good poetry must be not serious, but rather a serious demand and serious confrontation of the self with the inequalities and injustices of the world and, in this sense, the poem could never be tragic.

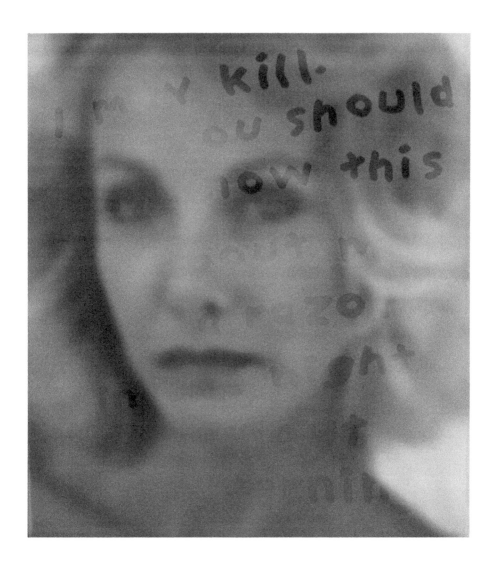

Jim Sajovic, *I may kill …*

Jim Sajovic: I continue to see the human body as metaphor, as an ineffable representation of the self. My works focus inwardly on the many thoughts, fears, and aspirations that make up the private, and often unspoken, reality of consciousness.

"Hix Fragments" are derived from the poetry of my friend and colleague H. L. (Harvey) Hix. Harvey's widely published poems pose humanistic, philosophical, and interpersonal questions with a sense of irony and mordant wit. What I look for are passages that seem poignantly visual. As I read, I sometimes imagine the face of someone involved in dialogue with me.

I have worked to capture a subtlety of facial expression, overlaid with fields of text, in an attempt to convey thoughts and feelings, sometimes spoken, sometimes suppressed, that lie at a threshold we are often reluctant to cross, whether from embarrassment or fear. I have enhanced the color, focus, and surface effects so that the image throbs and vibrates with an aliveness that confronts the viewer. I want to enchant and seduce the viewer, to draw the viewer in to read the text and to discover the subtext between the lines.

Susan Aizenberg

"Collaborations"

1. A poet and a painter walk into a bar. No, a painter and a poet walk into a museum. Neither has a parrot on one shoulder. The usual white hush permeates the gallery when the painter stops, turns to the poet, and brings his face close to hers. They're both a little drunk and she hasn't been listening, misses, as usual, his point. *Painting is clearly the superior art form,* he shouts. We move closer to the paintings, careful not to watch.

2. Is the text from H's poem in S's painting meant to be the woman's thoughts? A message scrawled across her photograph by someone else as a warning? I look at the image each day and today it looks to me as if her face is my own, reflected back to me in a mirror. I, or someone close to me, has fingered those words in steam on its surface.

3. *Ekphrastic poetry,* he also said, *is theft.*

4. A painter and a poet walk into a bar. No, this time a poet is asleep in a chair and the painter holds a camera. From the photograph he makes a painting of the poet sleeping and from the painting he makes another photograph, which he leaves in an envelope slipped beneath her door. The poet hates the painting, her loose body, slack mouth. The unmarked envelope without a note. That the painter feels a need to explain to her the nature of art.

The Real

HLH: I keep returning to this sentence on the next-to-last page of the book: "This could continue only by being a letter because what is most real is the person in the alcove or the object on the table or the shimmering idea." I think I'm drawn to it because it gives me a way to talk about why your book so resonates with me: I take it as — whatever else it's also doing — undertaking an intense inquiry into what is most real, on the tacit premise that typically we don't recognize the most real *as* the most real. I'm not coming up with a good way to end this "question" with a question mark, but I will be interested in any way you have of responding to it.

Lisa Fishman: I like your question-comment a lot. It appeals to me, the possibility that *Flower Cart* could be an inquiry into what is most real ... intuitively, I would like that to be the case, among whatever else the book is or is doing or undertaking.

It seems likely to me that it *is* the case, looking at the first lines in the book (following a letter from 1916 about corn): the first words of mine in the book are "As it would seem" (p. 5). When you put that together with the last poem, as you've quoted above ("what is most real"), your question makes even more sense. The corn letter itself, which opens the book, documents an inquiry into "what is something" (what type of corn is this?), and documents the answer that the corn in question was not any one thing; rather, it was "a distinct mixture of at least three different types of corn" (p. 3). The means by which this inquiry was made and resolved hinged on the physical sample sent with the letter, the residue of which remains visible on the paper 95 years later and which you can also see somewhat even in the reproduced letter in the book: the little holes on the left side, next to which is the handwritten note in ink, "This is the sample of corn sent to me," with a signature underneath — all of which is at the *top* of the letter proper.

I was fascinated by that piece of correspondence, partly because (I now think, in light of your question) it is an investigation into what's real. The corn was real, but what was it? Not one thing, a mixture.

I see that phenomenon of multiplicity being "discovered" in the last poem (the one you ask about), too. The poem appears to ask whether person, object, or idea is "most real." But the lack of a question mark helps the "or" in the series signify alternativity that isn't exclusive — i.e., the "or" to me reads as a bit closer to "and" because of the sentence structure and tone:

"This could continue only by being a letter because what is most real is the person in the alcove or the object on the table or the shimmering idea."

As if each thing — person, object, idea — could be that which is "most real": the answer is this or this or this. — Depending, perhaps, on "the emphasis"? On *how* it's said/thought/felt? Since the next paragraph begins: "Can you repeat that, with a different emphasis ..."

By that reading, there isn't any *a priori* "most real"; rather, the quality of realness is partly, at least, dependent on subjective means of making-what's-real, which is also what might be going on with the part of the poem that immediately precedes what you quoted:

"Well sometimes an object may be put to use. May be used to put together other things such as a very long walk through a small room, the smallest room in a person's face looking out at where the tree is not. The tree was cut down by the city after one branch broke in a storm. The tree was gigantic."

Such things as may be put together by means of (by the use of) an "object" are: a long walk (an action), a room in a person's face (space/person?), and where the tree (another object) is not (i.e., the missing object), and the space of its absence. The fact of a dubious ecology is provided as well, inasmuch as the authorities ("the city") cut the tree down after one branch broke in a storm. So, the highly figurative ("a very long walk through a small room, the smallest room in a person's face") immediately "looks out at" or opens out onto the literal, documentable fact: "The tree was cut down by the city after one branch broke in a storm." All of this is "put together," but by what "object"? That's not named or known, perhaps, but it's "what" allows the making, the mixture (of the unreal and the real?) to happen. Or it's what allows the mixture of the various "reals."

The real includes the civic context of votes being counted, and how being afraid within this context can be immobilizing. The work is "abandoned" at this time, but begins again the next day, by means, ostensibly, of "familiar elements" (blue poppies, foreign language) that, again, "may be all one thing."

The future is not real, by the terms of the poem, because it has not happened yet and is not (at least as it's defined commonly) "happening now." It never was and is not phenomenae. It's an abstraction, and I think it's used quite dangerously and deadeningly in much discourse and ideology.

At the center of the poem seems to be (1) "the present relation" of anything and (2) correspondence, insofar as the will to "[b]egin again" and continue the work depends on the writing "being a letter" — being addressed, being spoken to or being imagined to speak to another, as if the other, ultimately, is "the object" who may be put to use by making the making possible.

Your question also helps me notice the word "sidereal" in the poem, and I think of side-real, something being real (or being perceived as real) to the side of itself, so to speak — consonant with Dickinson, "aslant." That word, as the poem articulates, doesn't really know what it's doing there, but maybe sidereally it does ...

Finally, I might mention that the first sentences in this poem — "I like the acrobat by the sea. He chose not to include it." — allude to an early version of Wallace Stevens' "The Idea of Order at Key West." An early draft in his notebooks has just that — an acrobat on the shore — which, obviously, he took out.

The presence of Stevens in my poem at the end of *Flower Cart* and elsewhere suggests that your question is indeed prescient, for who was more concerned with the multiplicities of the real and its logic of alternativity than Stevens? Yet, it was my attraction to the deleted acrobat, the figure of agility and, to an extent, a transformer of reality — but not really, since the acrobat just works with physical reality differently — that got (as far as I know) Stevens into the poem here.

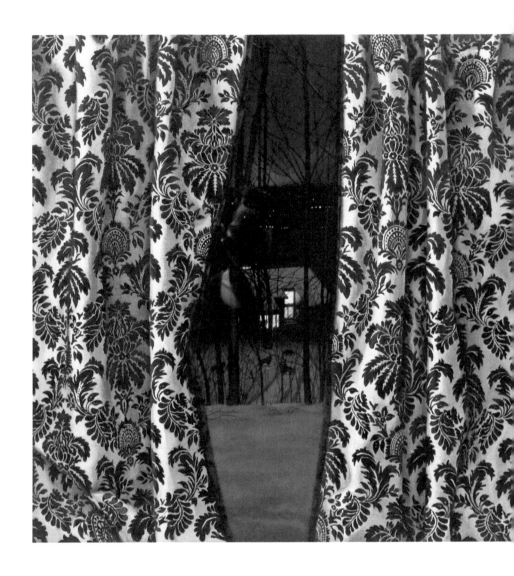

Leeah Joo, *Accidentally on Purpose*

Leeah Joo: Ten years ago, a series of self-portraits of reflections on the window-pane at night launched my work into a journey investigating the historical and the psychological implications utilizing the window as virtual stage caught between public and private spaces.

For centuries, to heighten the anticipation of the moment revealed in a painting, artists have painted curtains as an internal frame near the edge of their canvas to serve as a window into the pictoral space. This practice is attributed to the story of the contest between two ancient Greek painters, Parrhasios and Zeuxis. Zeuxis exhibited a painting of grapes, so realistic that a bird flew up to it. Then Parrhasios exhibited a painting of a curtain. Realism so convincing that Zeuxis demanded the curtain be drawn to reveal the painting behind it. In the 17th century, Vermeer, Maes, and other Dutch painters explored this idea by juxtaposing a trompe-l'oeil technique of undulating drapery or curtain addressing the flatness of the canvas over a carefully structured interior of a room depicting great depth.

The embodiment of a narrative in my drawings and paintings has been a long-standing constant in my work even as far back as a child growing up in Seoul with aspirations of becoming a manga artist. Naturally, I am drawn to all forms of narrative delivery and find inspirations in literature and cinema. The most poignant and lucid example articulating the richness of a window serving as a potent narrative framework is in *Rear Window* by Hitchcock. In the film, the character Jeff, played by James Stewart, spends countless hours in front of a window, obsessed with his neighbors; our voyeuristic fascination is tempted and satiated with these built-in picture frames of a home.

A poem by Charles Baudelaire called "Windows" eloquently summarizes my ongoing fascination of sitting before a dark window at night contemplating the scene unfolding on the glass.

> A man looking out of an open window never sees as much as the same man looking directly at a closed window. There is no object more deeply mysterious, no object more pregnant with suggestion, more insidiously sinister, in short more truly dazzling than a window

lit up from within by even a single candle. What we can see out in the sunlight is always less interesting than what we can perceive taking place behind a pane of windowglass. In that pit, in that blackness or brightness, life is being lived, life is suffering, life is dreaming ...

Jennifer Atkinson

"On Purpose"

after Leeah Joo's "Accidentally on Purpose"

Stylized vines and fantails — unvariegated, de-wildered

forms, the flat silhouette averages of May's

excess — repeat across the almost drawn

curtains that frame the framed picture.

Folds and shadows bend the leaves and flowerheads,

distortions to simulate the real. In the gap

where the drapes don't meet, dark

and the artist's barely visible self-reflection

interrupts. As if she held artifice aside

to permit us entrance through

her image to what seems unimagined outside:

snow gone blue with dusk, trees,

a neighbor's house and tiny tv-screen eye

awake and between the fore- and background planes

like-wild foxes, stiff with seeing

and being seen — eyes lit with distant glitter.

The World to Me

↦ WE SPEAK EASILY, "NATURALLY," about our physical bodies as *elemental*, whether by elements we refer to the four elements of the ancients, to the elements of the contemporary periodic table, or to some other array. We know what it means to say, "I am made mostly of water," or to say that "the four elements nitrogen, oxygen, carbon, and hydrogen make up 96 percent of the human body." But when we speak of our spiritual and experiential selves, rather than our physical selves, of what elements may we say those selves are composed?

The writers and artists in this section consider that question. Susan Moldenhauer, for instance, puts into question an array of spiritual/experiential elements in the photos of her *Place | Mind | Spirit* series, by composing them in such a way that "I am never sure about my placement in the composition, the scale of figure to background, or the movement of fabric at the moment of exposure": the film is exposed, but so is Moldenhauer herself, her spiritual self composed of placement, scale, and movement as *un*surely as her physical self is surely made of carbon, oxygen, and nitrogen.

Similarly, Warren Heiti is willing to accept for its elegance the description of his physical self as composed of earth, water, air, and fire, but he speaks of his experiential self as composed of such elements as memory, time, music, and light. This creates for him a sureness that is more like than unlike the

*un*sureness Moldenhauer exposes in her compositions: Heiti asserts, for instance, that "time may be an abstraction, but abstractions aren't unreal."

If, in the terms of chemistry, we are made of hydrogen and carbon, in the terms proposed by the visionaries in this section we are composed of such elements as finitude (Ackerson-Kiely), thought, emotion, and understanding (Drake), need (Atkins), effacement (Bond), idiosyncracy (Spahr), secrecy (Hardy), and reverberation (Gelineau).

Event

HLH: I'm interested in the mediating presence of birds here [*My Love Is a Dead Arctic Explorer*]. "This Landscape of Forest" (p. 18) ends "Your dark limbs laden with my favorite birds. Their happy song I am trying to make my way toward." Then, later in the book, "Anorgasmia" (p. 72) ends "Sometimes a bird sings in my chest. / I hold my breath. I squeeze your throat." In both cases, the bird is inside one person or another, and in neither case does the speaker herself sing. Why this unusual "placement" of the birds, this particular relationship to singing?

Paige Ackerson-Kiely: Thank you for your question!

I feel a little sheepish answering (the sheep is often in this body, but I have learned well to shepherd) what with the whole "Put A Bird On It" parody/skit from *Portlandia*. Oh, Harvey, there are so many things to just *get over*.

I live within walking distance of the Dead Creek Wildlife Management Area — 3,000 acres of wetlands, forest, and agricultural fields — a breeding ground for endangered birds (osprey, upland sandpiper, black tern) and an active migratory stopover for many species. The snow geese seem to attract a lot of binoculars.

My relationship with birds is pretty casual. They aren't really an event for me. I get to see eagles, owls, geese, and various herons regularly. I was trained many years ago in raptor rescue, and have transported downed birds to rehabilitation centers, though I have mixed feelings about this practice.

All this to say, the birds in these poems are pretty nonspecific, and really just a device to illustrate the speaker's inability to sing. I've used these birds — a fairly American practice — we use animals all the time in cruel and off-hand ways. I am a minister of my culture insofar as I, too, rely on animals to do my bidding, in my home, on my plate, in my poems. Who doesn't know, in the back of the brain, that nightingales shelter secret lovers, owls hoot

disappointment and impending death, eagles herald courage and strength? It is not something I am particularly proud of, hell, who is proud of a cycle of subjugation? We may derive imagined "gifts" from promoting this hierarchy, this speciesism, but in the end even the symbols and archetypes we ascribe to the "other" are a form of abuse. I've been abused and you've been abused, and on a very reductive level, that propagates all of our actions. It's why I can't stop eating flesh or thinking the apparition of birds in a poem I write means something greater. Because at one time or another, when I was laid out, it should have meant something to the one who put me there. I have to think it did. This is what we call "survival." Or what I call it. What I am calling it for now, until I learn something new, hopefully tomorrow. As the crow flies.

Of course, when I wrote these lines, they meant the world to me. It is fleeting, to have the world mean something, but what else is there? I know it sounds super elementary, but I am asking this for real! I ask this of every poem I encounter, my own, or others.

The "voice" of many poems in this book longs to sing, but cannot. She is aware of the finitude of joy and pleasure (expressed in both of these poems as birdsong), so chooses instead the lasting promise of the potential of pleasure (knowledge of the proximity of song, the song's pre-escape). In *Anorgasmia*, she is afraid that once the bird is let from the chest it will never be able to be caged again, and thus, if she experiences pleasure, she will lose the particulars of that pleasure forever. She only wants to contain the magnificent. Who doesn't? I chose that bird in a lazy way. It is easy to visualize it flapping about in the chest's delicate bone cage. The heart flutters; birds flutter. In *This Landscape of Forest*, she imagines the birdsong contained in the arms of an ideal lover she struggles to make her way toward. I like to think she will, eventually. In both cases. She'll find those birds, or set them free. Then they return, over and over again, whether they want to or not.

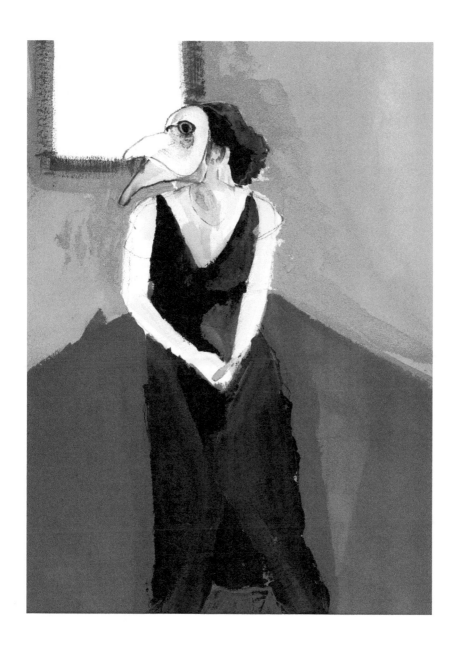

Christine Drake, *Siren Sketch 5*

Christine Drake: These gouache sketches on paper depict an interior world accessed through intuition rather than reason. The term *siren* is a reference to Greek mythology, creatures half-bird and half-woman. Human figures, singly or grouped, are arranged with simplified elements to suggest some bleak, mental interior. The masks the figures wear are a bridge that enables me to manifest visually my own metaphysical world in my own language. Without the masks, I would be stuck in exterior description, a realistic portrait.

Cynthia Atkins

"In Plain Sight"

> Incomprehensibility has an enormous power over us in illness ...
> — Virginia Woolf [*On Being Ill*]

I am certain of only one thing —

I am a team a team of (n)one.

 In the lineage, all things pass

through the kitchen, the mouth, origin

to the tribe. Smudged surfaces claim every trace

in the family cell — I moistened my tooth-brush,

 it came back with germs of madness —

Verdant and wet, just this side of the doormat,

pale footsteps left at the ajar

of an argument. One June afternoon, a feud

erupted (in the frozen food section).

It was hot as a dog's nap, when a baby cried out

 like a roadside bomb.

I kept smiling at the cashier, thumbing bruise-less

fruits, counting the dated canned goods.

It took hostages, sealed windows,

 taped my mouth shut

with sugar and pleasantries. I kid you not,

it pawned off my jewelry, blood diamonds

of /t/rust. I screamed out loud,

 but nobody answered.

I need to mind what matters most —

My sister needing a phone call,

my husband an apology, the time to watch

my son fumble a soccer ball down a muddy field.

 I am so clumsy

to the people I love. I've slid my tongue

on the sharp end of the conversation.

I am the form built to last, but made with

 cheap labor and parts.

(Do you *wanna trade your troubles for mine?* —

yours are manageable, and state-of-the-art.)

The dog watches my son when I'm not home —

 (I mean, *home*, but not).

Moments

HLH: The subject made explicit by the book's title, water [*Hydrologos*], is present throughout, from the title/first word of the first poem, "Rain," to the last image of the last poem, the sound of "tap water striking teakettle." But the sentence "Time is a symptom of music and light" (p. 23), in "Hourglass," names three other pervasive presences in the book. Is there any sense in which, for the poems in your book, time, music, and light function as "the first three dimensions" from which one "abstract[s] the fourth" (p. 23), water?

Warren Heiti:

Dear Harvey,

Thanks for your terrific and difficult question. I'd intended *Hydrologos* to be the first entry in a quartet of manuscripts, each dedicated to one of the four elemental dimensions (originally formalized, I believe, by the presocratic philosopher Empedokles), but that project was hijacked by others. Anyway, my untutored hunch is that water is more fundamental than and thus not abstractable from time. But it will take some time (!) to unpack that hunch. The sentence that you mention — "Time is a symptom of music and light" — is a perplexing one. While working on this manuscript, I found the device of the mask indispensable for thinking around the edges of the internal critical voice (the homuncular, premature editor who tends to yell through a little battery-powered bullhorn). This particular sentence was smuggled out of the underworld of primary process by its speaker (a character called "Ofelia") while I was trying to distract the cantankerous secondary-process censor.

Part of me continues to worry that the sentence is false; another, inarticulate part senses that it could be true. Aren't there deeper rhythms than the tick of the minute hand? The moving arc of the earth around the sun, for example? Couldn't the clock's reckoning be a symptom of the latter orbit? — Why do I hesitate? Is my hesitation itself symptomatic of a relapse into absolute

time, the picture of a super-refined line, a pure, unidirectional duration? Am I (inadvertently) imagining time as a peculiar kind of element in which music occurs?

— What is time? I don't often think about time, but when I do, I find it confounding.[1] However, it seems to me that linear time, the one-thing-and-then-another sequencing of histories and arguments, is mostly a reconstruction. That isn't how I experience time nor how I remember it. Mnemonic time seems far more archipelagic. Moments protrude like masses of earth out of the darker waters of the past, and the relations among them aren't primarily sequential. No, they're motivic. Or mnemonic time is like an art gallery. I remember wandering around an exhibition of Polish art from the turn of the twentieth century. I couldn't tell you the sequence in which I visited the rooms; but the painting of the harrowed "streetwalker" glows now, in the dusk of the gallery, beside the charcoal-eyed girl gripping the pale chrysanthemums and the black canvas with the tracing of a suicidal lake.

Memories are for me not primarily beads on an abacus, or boxcars on a track, but images. And the arrangement of such images into a narrative line may not preserve the most natural associations among them. (Compare: alphabetization is *one* way — a systematic and not unuseful way — of organizing books; nevertheless, one might feel that Rilke could be more fittingly shelved beside Wittgenstein than Russell.) Let me sharpen the point: if some associations among memory images are resonant, and if resonance is, in some sense, spatial (if it requires more than one dimension), then those associations won't be preserved by a representation in linear time. Insofar as I understand it, I find Jan Zwicky's account insightful: "Our 'idea' of time is a hypostatization of the *form* of resonance-insensitive thought. (A hypostatization of the form of what Freud called secondary process — i.e., roughly, language-dependent — thought.)"[2] Spinoza, on the other hand, says that time is imaginary. For him, it's also a hypostatization, but not exactly a function of resonance-*in*sensitivity; instead, it's a kind of *blurred* reverberation of the body. And he says that prophets are superlative imaginers, whose bodies are organs hyper-sensitized to still-distant vibrations. The difference, then, between prophets and the rest

of us is not unlike the difference (forgive the mechanistic metaphor) between an enthusiast's shortwave set and my $10 clock radio; the wavelengths are in the air, and what I hear as static, she picks up, crisply, as a Dutch news broadcast. I don't suspect that Spinoza's reduction works — time may be an abstraction, but abstractions aren't unreal — but it's awfully elegant.

That's a long circumnavigation of your nice question. I confess that I don't understand time, but thanks for the chance to think about it.

Warren

NOTES

1 But one poet and philosopher who does think carefully about both time and light is Sue Sinclair. See especially her *Mortal Arguments* (London, ON: Brick Books, 2003), *Drunken Lovely Bird* (Fredericton, NB: Goose Lane, 2004), and *Breaker* (London, ON: Brick Books, 2008).
2 Jan Zwicky, *Wisdom & Metaphor* (Kentville, NS: Gaspereau Press, 2003 and 2008), L72.

Susan Moldenhauer, *Wyoming (Susan), 2008*

Susan Moldenhauer: For more than 30 years, the landscape has inspired and grounded my photographic work. Seeking synchronistic, transformative moments when earth, sky, wind, and human presence are one, my images are made in one exposure — an ethereal performance in the landscape — captured in color and printed, uncropped, in monochromatic tonalities.

The *Place | Mind | Spirit* series (2004–2009) marked a return to my first passion in photography, the black and white print. It reintroduced the figure as a motif in my work — I am subject and artist — and furthered my experimental use of fabrics in the image-making process, which offered poetic resonances with wind and clouds, a spiritual presence, and transparency and opacity through light. Composing the image in the viewfinder, I could not know my placement in the composition, the scale of figure to background, or my movement with fabric that would be captured at the exposure's fraction of a second.

Bruce Bond

"The Invention of Clouds"

The clouds will eat most anything these days.

Effacement is the new face, less a mask,

more a seizure. At first we feared the haze

with all the longing of an obelisk,

we who rose up out of the open wound

and grasses of the plains, to find ourselves

among them, one part earth, another wind.

The monuments know what it is to live

enthralled inside the fog that blinds them,

not seeing the skies in light of being one.

If you are what you eat, do you become

in turn what eats at you. The steeple runs

to meet its maker, to separate the cloud,

its distant mouth. What is a past but lost

and everywhere you look, a living shroud,

which, in another light, could be the mist

of some chrysalis. World begets world

the way the fly begets the frog, the last

the lasting, and on it goes, our thunder spilled

like a face into the looking glass.

Sometimes, when I search for my lost friends,

they are so many clouds, buckets of light

pouring through the river. Which understands

less than it accepts. Like us. Effacement

is the new paradise, the water that bears

our heaven on its shoulders, a thing so large

it weighs nothing, or nothing that is ours

to measure. Who has not been on the verge

of breaking down, now and then, in pleasure

or pain, or both at once, to see your eye

drown in the eye it sees, the vague contours

of its planet plunged through another sky.

What we want terrifies. Cloud begets cloud

which in turn would vanish on our lips

if not for the need to breathe. The winds

move, and so push along the little ships

of leaves in the current, bound for shores

of the underworld, bearing in their hold

a small request, that they are never more

for being less, or one among the cold

drifts that are flocks of sheep led to slaughter.

Yes, you could see them that way, or called

downstream to pasture, cloud after cloud

that opens in the mirror, like a door.

Setting

HLH: Early in the book [*Well Then There Now*], these two lines appear: "Things should be said more largely than the personal way. / Things are larger than the personal way of telling" (p. 23). For me, these lines resonated throughout the book. They echoed back over the first section by way of reminding me of Leslie Scalapino's assertion that "individuals in writing or speaking may create a different syntax to articulate experience, as that is the only way experience occurs." They made me see the "swirl of connection" (p. 47) as centripetal rather than centrifugal, and the infusion of this work with fulfillment of the demand that "poets need to know the names of things" (p. 70) as enlarging. My question has to do with its relation to the last section, "The Incinerator," which seems to me the most "personal" part of the book in the way "personal" is often used when describing poetry: how does the attempt to say things "more largely than the personal way" inflect or temper or inform that section?

Juliana Spahr: Yes. "The Incinerator" is more personal. And yes, it is also not.

The first section of that poem, the one where the narrator is having sex with "Chillicothe," for instance, is stolen from some version of the screenplay for *American Beauty* that I found by google searching for something like "movie sex scene." I wanted some trashy and clichéd image of "violation" and innocence to rewrite and I didn't want it to be pornography but wanted something from mass culture. (I should probably point out that I have no interest at all in the fact of it being *American Beauty*, a movie that I have seen but have few feelings about or connections with. I was looking just for something generic.) Then I altered it some. I placed it in a cornfield, which is the cornfield of my memory from behind my childhood house. And by the end I started altering the bodies so the genders were no longer clear. And I cut all of this with passages from a critical study on Appalachia. And also some language from Muriel Rukeyser because I am obsessed with *Book of the Dead* and I thought of the poem as being in dialogue with both Rukeyser (who goes unnamed but appropriated) and Hannah Weiner (who is discussed in the center section).

So maybe it is "personal" in the sense that it is idiosyncratic to my thoughts in the moment I was writing it. And yes, the setting is personal. The cornfields of the backyard. And other parts come from memory too. I did spend some time in childhood with the neighborhood boy watching the trash burn. Very intense memory of the strike anywheres. And yet somewhat not "personal" in the usual sense of that word in that it is somewhat built out of mass cultural images and deliberately manipulated. I wanted this to be obvious but I couldn't figure out how to make it obvious because it also felt so arbitrary. Still feels like something I didn't deal with all that well in the poem. I've somewhat let it be read as "real," as "Chillicothe" just being a name replacement rather than a use of a cliché.

The alphabetized lists in that poem are a mixture of personal memory and Wikipedia information (again, going for the obvious) and some books and articles about Appalachia. I thought of the first list as pre-NAFTA. And then the second list as post-NAFTA. Both because NAFTA brought big changes to the economics of the region (the papermill that loomed so large over the town during my childhood was owned by Mead and they quickly pulled out when they could; the mill still limps along somewhat "worker owned"). And because around the time of NAFTA I grew up and left the town.

But there is another story, a personal and idiosyncratic one, here that is almost said ... I wrote this around the time that Stephanie Young and I had published that article "Numbers Trouble" and there was all this talk on the webbernet about the numbers and what they meant. And I was struck by how often when the numbers talk got too intense, there was a tendency for someone to tell a story about the economic situation of their childhood. So several times people said oh the numbers don't matter and then credential themselves by saying something about being working class. But often they were no longer working class and they would be saying something about their childhood. And I wanted to try to think about that gesture. Somewhat about why narratives about class often seem stuck in childhood. And what it means to try to see one's personal story within larger economic changes.

Leah Hardy, *Listen*

Leah Hardy: Childhood labors of love included making shoebox dioramas, assembling insect collections, and creating secret spaces; these innate endeavors have greatly inspired my artwork as an adult. My sculpture is a visual diary for commentary on daily occurrences, dreams, travels, and human interaction — where I try to make sense of the world and its mysterious events in a poetic, distilled narrative manner. Fragments of the human body, flora/fauna, and everyday objects are integrated into surreal shrinelike settings to memorialize strange — and wonderful — life experiences.

Christine Gelineau

"Act as Object"

listen : when activating
 the stasis
is the eye the ear?

If the act were object
it could shape itself so :

 hammered lily
that graphs the spinning phonemes :

 petal-flared pinna
fin flipper feather
 with hollowed calamus
to describe the lozenge
 of language :

 honeyed patina
of the auricle funneled
inward
channel to canal :

ear drum of the hollowed

 base timpani

 of the boxed cochlear.

Here where sound

 is an invertebrate swirled

 in its metal shell : shell

embroidered with indentations

 and slender canines :

why not as well the voice

 box

 reverberating

sound flowing out

 that opened

 throat the coppery

 furled lip?

If act were object could we not hear :

 speak / listen as

 conjugations of a singular

 verb?

And Their Shadows at the Same Time

↦ *What* WE PERCEIVE cannot be separated from *how* we perceive. This holds in the simplest way one might mean it: I see what I see because my eyes respond to light waves within a certain frequency range, and I don't see what I don't see because it occurs outside that range. I hear what I hear because it has a certain volume and frequency; a bat hears other things, hears (in some important sense) *more*.

The savants in this section see various objects, and see vario*usly*, but all seek to understand and enliven and expand their perception. Kirsten Kaschock tries through the act of naming "to see a flicker of the essential ... and to call it out." Daniel Dove makes self-reflection more capacious by "combining observational fidelity with obvious facture." Christopher Leitch renders uncertainty "liberating and invigorating" by employing "random materials and indeterminate processes." And so on.

Their decisions for themselves also issue invitations to us: not to accept our isolation from one another (Kaschock), willingly to suspend disbelief (Carter), to question "the long-term sustainability of the consumer-driven market model" (Shadwell), to "prepare a space for the imagination with what happens to be closest to hand" (McCutchan), and so on.

This section appears last in the book, and Alison Calder's poem appears last in this section, because they seem to me to offer particularly clear embodiments of an ambition I take as extensible to all the interlocutors in the conversation this book creates: they set themselves, and imply that it would be well for any one of us to set herself or himself, to see "shapes and shadows at the same time."

Failure

HLH: As indicated by its title, and by such instances as "Baby Names: Girl F" (p. 21), the book [*A Beautiful Name for a Girl*] is preoccupied with naming. But one specific instance of naming gives me a way to formulate my question: "Bad Night, Bad" (p. 78) begins, "Each star hangs / on a separate bolt of silk and by a different name / claims the universe." Here an act of naming claims the universe. Is this representative? What, for you, for these poems, is the hold, the power, of naming?

Kirsten Kaschock: Naming is inescapable. Because it is language. How language corrals thought. I love names: the singularity, the known-ness of being named. But it is also a terrible thing — to be named. One thing is not another; we insist on it, I think. So names are prisons. My reason for writing many of the poems in this book is to insist that one can be one thing and also be another. To show how these prison cells are membranous — possible to pass through. As in birth. As in death. As in coming home from work, or being needed, or the time travel of a long train ride. We are capable of being other.

People have identities. Plural. We are all Clark Kent; all Sons of Sam. Double living is not fiction: it is mundane. And even if I were only one thing, that thing would not always be the same thing. Our inner monologues can show our Hydes to us.

The first line in *A Beautiful Name* ... is: "This is the house Jane built." I think that I am probably talking about identity, but also about the problem of using life as a way to establish identity instead of living. In that poem, Jane's name is repeated over and over, as if the key to unlocking the house of language is to make strange the foundation, the given. There is a word for that: ostranenie. I love that word. It sounds like the name of a little French girl who can't stop making fun of me. Because, I suppose, I am dramatic.

To name is to see a flicker of the essential (yes, I believe) and to call it out. Once it is out, however, it becomes an edifice, a structure, an institution. The impulse to name is to utter recognition: *it is you!* But we fall in love with the sound of our own voice and the names become hollow. I don't know who you are, I just like the sound "you" make as I sing you to myself.

So, I guess I am trying to shatter names. Or, I'm trying to reinvest them with love. Naming is always a failure, but I believe in the beauty of failure. To be doing what I can. I believe in our isolation from one another and the way we can't accept it. I have lived that. I've been a box. As you are also a box. Because we are both boxes, we bleed. And that's another human thing: bleeding together. If we push through our cells and into each others' — it will be either the beginning of a great escape or a new and contagious cancer. It is naming that will tell us which.

Daniel Dove, *Odeon*

Daniel Dove: My recent paintings depict fictional, once-grand environments that have fallen into ruin. Whether originally built for purposes of entertainment, social organization, or manifesting a utopian dream, these places are now marked by weather, time, and unplanned interventions. In this respect, they have lost their transcendence and become unruly, unplanned, and emphatically material. My hope is that the highly varied facture of painting captures this transformation while also building a beautiful image, replete with feeling and the possibility of intense perceptual experience.

Ann McCutchan

"Garage"

When I was a child in south Florida, my family moved into a white concrete-block house with a double garage, a few blocks from the beach. Like other families there in the 1950s, we often kept all the windows open, and the garage as well, to welcome the moist, salty breezes sailing in and out. Inspired by the *Ed Sullivan Show* on TV, my sister and I turned that wide, drafty space into a staging area for doll beauty pageants, guinea pig races, and magic tricks with quarters hidden in bandanas, plates spun briefly on curtain rods. But I remember the garage best as an auditorium for the variety revues we presented within, starring all the neighborhood girls willing to bear my directorship. For as the oldest on the street, by rights the bossiest, and the one who wanted most to perform, I usually thought up these productions in the first place.

Now, fifty years later, I recall nothing of story lines, and little of the music we broadcast on the suitcase record player past Bizet's *Carmen Suite*, Victor Herbert's *Babes in Toyland*, and Stravinsky's *Firebird*, to which we contrived a scene where Maid Marian and Robin Hood escape the Sheriff of Nottingham by hiding behind a surfboard. Our dance numbers mimicked the tap routines we were taught at the Kathryn Whipple School of Dance in the sandy strip shopping center out on Dixie Highway, and our costumes

came straight from our spring recitals. Oh, how we skipped and kicked and twirled on the oil-spilt garage floor, lockstep in soft pink tutus, Royal madrigal capes, white-and-silver princess skirts, the flutter of feet, the loft of raiment transfiguring us as blithe sylphs, awakened beauties.

To showcase these entertainments, which parents paid ten cents to attend, my sister and I transformed the garage from a dank concrete cave to an auditorium, never mind the storage cabinets, workbench, and garden tools lurking along the walls. Given two old bed sheets to work with, we devised both a backdrop and a curtain, hand-coloring the rotten cloths with our favorites from a 64-count box of Crayolas — Bittersweet, Umber, Cornflower — and hung them up, the backdrop taped against the cabinets, the curtain strung out between an antique bedstead at one end and an elevated lawn mower at the other. To keep the sheets from lifting in the breeze, we anchored the hems with coconuts harvested from the back yard.

This was the part of "putting on a show" I liked best. I'll never forget the anticipation rising from the dogged hand-coloring, the floating and draping of sheets, the shaking of palms for their weighty, sloshing fruit. What would we make in our garage? Who would join in? Who would attend? Possibilities skittered within me like neon fish, promise turned my face toward the gleaming sun. Even today, this remains my greatest thrill: to prepare a space for the imagination with what happens to be closest to hand.

Uncertain

HLH: From the very first poem, "this learning to tell time," this book [*The Whole Marie*] makes a regular practice of adding to, subtracting from, and creating variations on, words or phrases, right through to the end (as in "A boy who is a fiend" on p. 82). Is this a way of inviting language to guide perception, rather than vice versa? Or is there a different design behind it?

Barbara Maloutas: Thank you for asking this question. In *The Whole Marie*, the most complete and obvious use of addition or subtraction to words is "this learning to tell time." It is a method of exploration and creation that invites language to guide perception but also invites us to recognize a kind of form making practiced in the visual arts, almost as in concrete poetry. What is not present, the negative (shape), is as important as what is present. And what is not there, creates other meaning and form. You might say that I practice a blending/blurring of visual and literary art. This is perhaps surface but I think all I can do is give you examples of what interests me and why, and that does not come out of scholarship, but curiosity.

On the other hand I've collected 40 pages of "Indo-European Roots" (pp. 2094 to 2134) and no longer know the source of the material. As an example, I find the depth of ak- fascinating for its connections and associations.

Germanic *aiwi; **b** from Germanic *aiwi + *wihti, "ever a thing, anything" (*wihti-, thing; see **wekti-**). **2.a.** Suffixed form *aiw-o-. COEVAL, LONGEVITY, ME-DIEVAL, PRIMEVAL, from Latin aevum, age, eternity; **b.** suffixed form *aiwo-tā(ti)-. AGE; COETANEOUS, from Latin aetās (stem aetāti-), age; **c.** suffixed form *aiwo-t-erno-. ETERNAL; SEMPITERNAL, from Latin aeternus, eternal. **3.** Suffixed form *aiw-en-. EON, from Greek aiōn, age, vital force. [Pokorny aiu̯-17.] See also *yuwen- under **you-**.

ak-. Important derivatives are edge, acute, hammer, heaven, acrid, eager[1], vinegar, acid, acme, acne, acro-, and oxygen.

ak-. Sharp. **1.** Suffixed form *ak-yā-. **a.** EDGE, from Old English ecg, sharp side, from Germanic *agjō; **b.** EGG[2], from Old Norse eggja, to incite, goad, from Germanic *agjan. **2.** Suffixed form *ak-u-. **a.** EAR[2], from Old English æhher, ēar, spike, ear of grain, from Germanic *ahuz-; **b.** ACICULA, (ACU-ITY), ACUMEN, ACUTE, AGLET, EGLANTINE, from Latin acus, needle; **c.** ACEROSE, from Latin acus, chaff. **3.** Suffixed form *ak-i-. ACIDANTHERA, from Greek akis, needle. **4.** Suffixed form *ak-men-, stone, sharp stone used as a tool, with metathetic variant *ka-men-, with variants: **a.** *ka-mer-. HAMMER, from Old English hamor, hammer, from Germanic *hamaraz; **b.** *ke-men- (probable variant). HEAVEN, from Old English heofon, hefn, heaven, from Germanic *hibin-, "the stony vault of heaven," dissimilated form of *himin-. **5.** Suffixed form *ak-onā-, independently created in: **a.** AWN, from Old Norse ögn, ear of grain, and Old English agen, ear of grain, from Germanic *aganō, and **b.** PARAGON, from Greek akonē, whetstone. **6.** Suffixed lengthened form *āk-ri-. ACERATE, ACRID, ACRIMONY, EAGER[1]; CARVACROL, VINEGAR, from Latin ācer, sharp, bitter. **7.** Suffixed form *ak-ri-bhwo-. ACERBIC, EXACER-BATE, from Latin acerbus, bitter, sharp, tart. **8.** Suffixed (stative) form *ak-ē-. ACID, from Latin acēre, to be sharp. **9.** Suffixed form *ak-ēto-. (AC-ETABULUM), (ACETIC), ACETUM; ESTER, from Latin acētum, vinegar. **10.** Suffixed form *ak-mā-. ACME, (ACNE), from Greek akmē, point. **11.** Suffixed form *ak-ro-. ACRO-; (ACROBAT), ACROMION, from Greek akros, topmost. **12.** Suffixed o-grade form *ok-ri-. MEDIOCRE, from Latin ocris, rugged mountain. **13.** Suffixed o-grade form *ok-su-. AMPHIOXUS, OXALIS, OXYGEN, OXYURIASIS, PAROXYSM, from Greek oxus, sharp, sour. [Pokorny 2. ak̑- 18, 3. k̑em- 556.]

akʷ-ā-. Important derivatives are island, aquatic, ewer, and sewer[1].

akʷ-ā-. Water. **1.** ISLAND, from Old English īg-

I referenced these sheets for my latest chapbook entitled *of which anything consists* (Diagram/New Michigan Press). The roots for water, air, earth, and fire are of course covered and curious here. I live with a non-native speaker and feel like I am always translating to some extent. I lived in Europe for five years while studying design and am very conscious of translation. See p. 9 in *the whole marie* where I add to and change sentences one word or phrase at a time to slowly reveal a state of mind, "Possessive Pronominal Adjective."

In *the whole marie*, on p. 82 (and yes, we have to refer to page numbers because themes are woven, not explicit, and both obscured and revealed as the reader moves along from one level to another with images and psychological states popping up and flattening out) boyfriend becomes fiend by the removal of one letter. What parent hasn't thought of these two concepts at one time and in almost the same breath?

In the same long poem, for section XIII, where I write, "No touching. No nakedness. / There is propriety. Especially," I make the connection in the following section "... from some obscure motive of propriety ... / Etymology? F. property." This playing with words and letters can be serious business or lighter as in "One from Mexico / to absorb the heat. // *r* and *t* are right next to each other. // It wrote heart at once. Unasked for."

Litmus Press published an editorial submission in *Aufgabe # 3* that rather directly shows my method of entering language, from a side door, so to speak:

Leaves: and their uses as nonsense

A chance outline for the consideration of A. Goldsworthy's work in southwest Scotland

Leaf, or *loof, laub, lauf,* and (etymologically) as far as lodge and lobby

 Collect and/or divide leaves by color and kind:

 Season and kind determine color. Harvest green leaves in the summer, directly.

(*A leaf is an organ borne by the stem of a plant.*) There are specific weeks in autumn when the color or colors are most intense. Seasons impose deadlines. Lungs are organs inside.

Color and leaves

Leaves of one color make bigger impact or distinction. The multi-colored leaf is suitable for camouflage in context of the untouched forest – itself, impossible. Temperature and color are linked – in time.

Dry leaves

Ones of varying colors are difficult to handle as they tend to curl and blow away. Moisture is a tool.

Wet (adj.) leaves

Wet (v.) leaves by adding water to a fresh autumn harvest. Wet leaves can be applied to such locally found objects as rocks, boulders, fallen tree limbs or rivers.

Rivers are a particularly interesting bed.

A bed is a plane

Occasional turning pools

A river is contained

Linear movement

Energy patterns disturb linearity and are based in materiality

In flotation there may be immobility through anchoring

Quality of shadow depends on sunlight, depth, texture and speed or lack of it

Ripples

Other Considerations

Moisture supports decomposition

The subject as transience

Problems as a good teacher

Leaves and their uses as multiples joined:

The use of thorns, grass stalks or other methods of joinery (such as water) are necessary but not often lasting.

Joining may produce linear or specific and shapeless flats

Shapeless flats present the least distinction and may be mistaken as native

Specific flats can be extremely intrusive

Considerations of a new place and where touch begins

The craft can be learned and refined – with patience – over years

Assistance happens:

Reasonable speed is vital. Helpers are essential. Once acquiring a reputation, these are easy to gather. There will be many who wish to be part of a record or trace of nature. There remains the question of whether an end is ever an end.

Thank you again for your inquiry and I hope this offers a small opening into my methodologies and interests.

Christopher Leitch, *2 breaths*

Christopher Leitch: I am working with random materials and indeterminate processes, and I never know what anything is going to look like. This uncertainty is liberating and invigorating.

Supriya Bhatnagar

"Misstep"

She glides in, as if sleepwalking. The room is almost bare. Remnants of the party are strewn about. A streamer here, a balloon there; a piggy-face balloon. All that is left are the memories. Memories that will fade with time. She hears voices from the corner. Whispering. Are they talking about her? Are they accusing her? Are they judging her? She is invisible to them. Look at me! She tries to shout, but no voice. I am here! But no one sees her. Glasses are raised in a toast, but not to her. She cries, and mascara streaks down her cheeks. Black, ugly streaks. She wipes her tears off, and now her cheeks are gray. Ashen. The clinking of glasses is musical, soothing. She tries to pick a glass from a tray, but it falls and shatters … the blue Curacao flows away.

Disappearance

HLH: Because "After the Rain," with its "glance of one / not looking straight ahead," is one of my long-standing favorites among your poems, I thought of it when at the end of the very first poem in this new collection [*A Dance in the Street*] the "something rustling / through the timothy grass" looks back, turning, "every so often, / to make sure I'm coming" (p. 5). And then I begin to see other instances of sideways glances, looking askance, impeded vision, and so on. (E.g., the father, seen and seeing through window glass, but disappearing upon approach [pp. 22–3]; the sight-destroying vinegar in the epigraph to "Senmurv" [p. 53]; the son-mediated seeing of the woman in "At the Art Institute" [pp. 61–3]; the vanishing into the dark of the mourning dove [p. 88]; and so on.) Are these forms of appearance/disappearance, these attempts to see what is and isn't there, perceptual correlatives for the experience (and the fact) of disappearing history?

Jared Carter: Thank you for noticing the book and for sending me your query. You've pointed to several poems in the collection in which "appearance/disappearance" seems significant.

Although "history" may be said to be included in what is disappearing, I think a more inclusive term might be "existence." Things come into being, exist for a while, and then disappear. Two additional poems focus on this process.

In "Summit" (p. 15), at the end of the first section, the speaker explains that he could not discover anything left of the village that once stood at the top of the hill. By the end of the poem all he could find was "the land itself, and the way it still rose up" (p. 16). He both sees/doesn't see what is/isn't there.

In "War" (p. 60) our attention is drawn not only to the specific images Goya provides but also to the background cross-hatching. It provides context for the images and could be said to be, in effect, the ground of their being. They stand against it, and it emerges seemingly out of nothingness.

Some of these poems are narratives, and fairly realistic ones. They ask the reader to suspend disbelief and assume, for a short time, that the various narrators are describing something that happened "in the real world" (the one the grade-school students are always asking about).

Of course it did not. We are simply encountering arrangements of words that can yield temporary illusions of action, continuity, or meaning — and only to certain receptive readers. But such manifestation lies at the very heart not only of illusion but also of existence itself.

Poetry can help reveal this existential core — that ground of being, that process of appearance/disappearance that we often tend to overlook or forget. If the philosopher strives to understand this core, and the physicist attempts to demonstrate it, the poet hopes to show it, sometimes by borrowing metaphors from the others.

Take, for example, the black hole, the surface of which we were earlier led to believe would swallow forever any information or coherency that approached it. It is this kind of oblivion that good poems seem to be opposing, despite the ultimate impossibility of doing so.

Yet we have learned more recently from Hawking and others that there is black-body radiation or evaporation from black holes, and that theoretically, in time, black holes that lose more mass than they gain through other means will dwindle away. They do not appear forever, then; they also disappear.

To take another instance of the slipperiness of being: As shown most conveniently in Feynman diagrams, and as experiments have confirmed, collisions of elementary particles have the same weight when run either backward or forward in time. The laws of nature are time-reversal invariant, and I suggest that the same may be said of certain poems.

In the first poem in the book, "Prophet Township" (p. 3), we cover a considerable interval of time — from the late nineteenth century, at least, to the present.

The narrator doesn't really enter the abandoned farmhouse shown toward the end. Instead he remains in his car and *imagines* what will happen if he approaches the house.

What else might he be thinking? About everything else the poem has to offer — the early farmers of the previous century, with their front parlors, their watched-over coffins, their frozen horse-troughs. About his jobless contemporaries building a fire in the parlor. He is, in effect, traveling backward through time.

What he perceives at the end of the poem is that some things disappear while others reappear. There always seems to be some remnant, some avatar, some middle C still sounding in the darkened warehouse room (p. 21). This is akin to the black hole's opposite movement, radiating outward, escaping what was once assumed to be eternal oblivion.

Such reappearance is personified, at the poem's end, as the breath of wind that seems in its own way to sense *his* presence — a presence that he in turn has imagined or caused to appear, as he sits in his car, just as we are imagining him and the entire poem as we read through it.

The poem as loop, then, or even Möbius strip, coming into being in the midst of disappearance. I sense this tendency in many poems that I admire. "The Song of Wandering Aengus" or "Stopping by the Woods" or "Now Sleeps the Crimson Petal" do not run from beginning to end like a windup toy.

They are more like emerging clusters, minor galaxies of words. As brief as they are, I can, for a moment, be drawn into them, even lost against their event horizons. At the same time, some part of me begins to radiate outward from them.

Nothing like this happens, of course, if you regard the poem as a tract or a treatise, with a beginning/end and some sort of extractable content, and then set the language aside and attempt to summarize what you've just read.

Try approaching it instead as a singularity, a small universe of appearance/disappearance that has just popped into existence out of a near-infinite sea of other infinite poems popping and bubbling out of zero quantum vacuum.

Expansion takes place in each of these mini-universes for an unpredictable interval. Few will inflate to the size of *Paradise Lost* or *Moby-Dick*. Perhaps the poems we normally encounter expand only to the dimensions of those contained in my book. Or yours.

"Mourning Dove Ascending" (p. 88) could be thought of as pure loop or bubble, but one in which a strong anthropic principle holds. The bird appears, and for a moment you can halfway recognize it, because the two of you inhabit a macro-world calibrated in ways that make such perception possible. Or such illusion.

Now you see it, now you don't. Whack-a-dove. It is calling, it is not calling, now its wings make a different sound, it is disappearing. But isn't it still calling? It is a part of nature, and in this particular universe nature is time-reversal invariant.

In "Snow" (p. 90), at the end of the book, isn't the snow still falling?

Shelby Shadwell, *Low Pressure 2*

Shelby Shadwell: *Low Pressure*: I am responding to how one accesses the contemporary western landscape — primarily through relationships formed traversing roads, interstates, and highways. The source imagery for the work comes from the periodic snapshots taken from the network of cameras monitoring road and weather conditions available on the Wyoming Department of Transportation website. The pictures that the cameras take are ephemeral, lasting only a few minutes before replacement. I search through the randomness to find compositions that formally intrigue me and manipulate the images through the drawing process, creating objects that attempt to transcend the fleeting nature of their source.

For me, the images these cameras taken during periods of especially harsh weather speak to a sense of political and economic unrest currently facing the nation. The title for the work, *Low Pressure*, comes from the cameras and is ironic, as the weather creates extremely dangerous traveling conditions for motorists and uncertainty grows not only about the prospects of economic recovery, but also about the long-term sustainability of the consumer-driven market model. With the addition of video installation to this body of work, I look forward to expanding my investigation greatly.

Alison Calder

"Driving to the cabin in the dark"

Driving to the cabin in the dark, hour ten

from Winnipeg, ten hours heading west then north,

passing grain elevators, Dairy Queens, gas stations, smoking fields and,

some would say,

nothing:

the headlights show shapes and their shadows at the same time,

blown-out tire fragments like awkward birds, *trompe l'oeil* trash

bordering the edges of the eye.

The night, projected on the windshield, narrows

to a grainy screenshot, projector stuck on a particular frame.

In the dark, we could be moving or staying still,

the world replacing itself at convincing intervals.

Now and then, yard lights: there could be life there.

One time when we drove past Quill Lake,

the town was burning its elevator, bonfire huge and pagan,

small figures illuminated briefly as we passed.

It was like something out of history,

a town burning its own, consuming itself.

Then it was gone, rear-view access only,

invisible and *vanished* not synonyms

though both apply.

Now though, snow. Switching to brights shows it

skewing like static across the window,

drawing us from one ditch to the other.

The edges here, as everywhere, are blurred,

space collapsing into time. Two hours still to go.

Coming up to Melfort the cold street lights show us

each other, harsh and hollowed in their acid glare.

Cars in the ditch on both sides of Highway 6, a trailer

jackknifed across one lane.

Someone waves us by. No need for us.

In the empty parking lot of the high school we debate

going on, turning back. Right now

it's Storm of the Century; tomorrow morning

the snow could melt into a footnote. From this moment

it's impossible to tell.

Works about Which Interview Questions Are Posed

Ackerson-Kiely, Paige. *My Love Is a Dead Arctic Explorer.* Ahsahta Press, 2012.

Beachy-Quick, Dan. *Circle's Apprentice.* Tupelo Press, 2011.

Brown, Lily. *Rust or Go Missing.* Cleveland State University Poetry Center, 2011.

Carter, Jared. *A Dance in the Street.* Wind Publications, 2012.

Gillian, Conoley. *an oh a sky a fabric an undertow.* Albion Books, 2011.

Cooperman, Matthew. *Still: of the Earth as the Ark which Does Not Move.* Counterpath Press, 2011.

Fishman, Lisa. *Flower Cart.* Ahsahta Press, 2011.

Golos, Veronica. *Vocabulary of Silence.* Red Hen Press, 2011.

Hanson, Julie. *Unbeknownst.* University of Iowa Press, 2011.

Heiti, Warren. *Hydrologos.* Pedlar Press, 2011.

Kaschock, Kirsten. *A Beautiful Name for a Girl.* Ahsahta Press, 2011.

King, Scott. *All Graced in Green.* Thistlewords Press, 2011.

LaMon, Jacqueline Jones. *Last Seen.* University of Wisconsin Press, 2011.

Magi, Jill. *SLOT.* Ugly Duckling Presse, 2011.

Maloutas, Barbara. *The Whole Marie.* Ahsahta Press, 2009.

Martínez, Valerie. *Each and Her.* University of Arizona Press, 2010.

Maxwell, Kristi. *Re-.* Ahsahta Press, 2011.

Osman, Jena. *The Network.* Fence Books, 2010.

Purpura, Lia. *Rough Likeness.* Sarabande Books, 2011.

Rekdal, Paisley. *Animal Eye.* University of Pittsburgh Press, 2012.

Savich, Zach. *The Firestorm.* Cleveland State University Poetry Center, 2011.

Simonds, Sandra. *Mother Was a Tragic Girl.* Cleveland State University Poetry Center, 2012.

Sinclair, Sue. *Breaker*. Brick Books, 2008.

Skibsrud, Johanna. *I Do Not Think That I Could Love a Human Being*. Gaspereau Press, 2010.

Spahr, Juliana. *Well Then There Now*. Black Sparrow Books, 2011.

Taylor, Catherine. *Apart*. Ugly Duckling Presse, 2012.

Teare, Brian. *Pleasure*. Ahsahta Press, 2010.

Wakefield, Kathleen. *Snaketown*. Cleveland State University Poetry Center, 2010.

Woodward, Jon. *Uncanny Valley*. Cleveland State University Poetry Center, 2012.

Young, Laurie Saurborn. *Carnavoria*. H_ngm_n Books, 2012.

/ Artworks Reproduced

Checefsky, Bruce. *#13*

Devaney, Anne. *Late Summer*

Dobbelaar, Ien. *hombre y niña*

Dodge, Jason. *Above the Weather*, 2007

Dove, Daniel. *Odeon*

Drake, Christine. *Siren Sketch 5*

Dupont, Brian. *Catastrophe*

Germen, Murat. *Truth Is Stranger Than Fiction*

Hardy, Leah. *Listen*

Henriquez, Alisa. *Resolve*

Herman, Adriane. *A Good Cry*

Hook, Phillip Michael. *The Weight of Winter*

Hooper, Cassandra. *Landscape (Wild Turkey)*

Joo, Leeah. *Accidentally on Purpose*

Lackey, Jane. *golden maze, west*

Leitch, Christopher. *2 breaths*

Lindberg, Anne. *motion drawing 03*

Mann, Katherine Tzu-Lan. *Maw*

Marks, China. *Drink Me!* (2005)

Mills, Thomas Lyon. *Caroga*

Moldenhauer, Susan. *Wyoming (Susan)*, 2008

Premnath, Sreshta Rit. *A Cage Went in Search of a Bird*

Rahmani, Aviva. *Lane's 1*

Russell, Doug. *Ebb and Flow #2*

Sajovic, Jim. *I may kill ...*
Scekic, Vera. *Untitled (phthalo stain)*
Shadwell, Shelby. *Low Pressure 2*
Trilling, Gerry. *Hidden Minority*
Von Mertens, Anna. *The Duke and Duchess of Urbino's auras, after Piero della Francesca*
Walko, Sarah. *We explained we breathe through glaciers ...*

/ Acknowledgments

Anna Von Mertens, *The Duke and Duchess of Urbino's auras, after Piero della Francesca* 2009, hand-dyed, hand-stitched cotton, 18" x 13" (each)
courtesy of the artist and Elizabeth Leach Gallery
photo courtesy Don Tuttle Photography

All other artworks reproduced courtesy of the artist.

Alison Calder, "Driving to the cabin in the dark," from *In the Tiger Park* (Coteau Books, 2014), reproduced by permission of Coteau Books.

All other texts (poems, prose pieces, interviews, and artist statements) reproduced by permission of the author.

Particular thanks to Carol Moldaw, whose individual contribution suggested the title under which the whole conversation now is presented.

No artistic experiment of this sort and at this scale could occur without a robust collective goodwill from all involved. I am grateful to the participants in this conversation, for the *fact* of their contributing to it and for the profundity and beauty of *what* they have contributed.

I am grateful to Brian Henderson for creating the conditions that made possible this conversation's existence as a book, and grateful to him and the staff of Wilfrid Laurier University Press for fulfilling those conditions, realizing the conversation in this form.

For the rich and layered conversation of lives shared, I am grateful to Kate Northrop.

/ About the Curator

H. L. Hix is the author (or editor or translator) of more than twenty-five books, including the recent poetry collections *I'm Here to Learn to Dream in Your Language* (Etruscan Press, 2015) and *As Much As, If Not More Than* (Etruscan Press, 2014). He lives in the mountain west with his partner, the poet Kate Northrop. His website is www.hlhix.com.

About the Contributors

Paige Ackerson-Kiely is the author of the poetry collections *In No One's Land* and *My Love Is a Dead Arctic Explorer*, and other works of poetry and prose. She lives in Vermont and works at a homeless shelter.

Susan Aizenberg is the author of three collections of poetry: *Quiet City*, forthcoming from BkMk Press in 2015; *Muse* (Crab Orchard Poetry Series/SIUP 2002); and a chapbook-length collection, *Peru*, in Graywolf's *Take Three/2: AGNI New Poets* Series. She is co-editor, with Erin Belieu, of *The Extraordinary Tide: New Poetry by American Women* (Columbia University Press, 2001).

Nin Andrews is the author of several books including *The Book of Orgasms, Why They Grow Wings, Any Kind of Excuse, Midlife Crisis with Dick and Jane, Sleeping with Houdini*, and *Southern Comfort*. Her next book, *Why God Is a Woman*, is forthcoming from BOA Editions.

Renée Ashley is the author of a novel and five volumes of poetry — most recently, *Because I Am the Shore I Want to Be the Sea*. She has received fellowships from the New Jersey State Council on the Arts as well as the National Endowment for the Arts.

Cynthia Atkins is the author of the *Psyche's Weathers* (CW Books, 2007) and most recently, *In the Event of Full Disclosure* (CW Books, 2013). Her poems have appeared in *Alaska Quarterly Review, BOMB, North American Review*, and *Verse Daily*, among many other publications. She is assistant professor of English and lives on the Maury River of Rockbridge County, Virginia.

Jennifer Atkinson is the author of four collections of poetry. The most recent, *Canticle of the Night Path*, won Free Verse's New Measure Prize in 2012. Her poems have appeared in journals including *Field, Image, Witness, New American Writing, Poecology*, and *Cincinnati Review*. She teaches at George Mason University.

Dan Beachy-Quick is the author, most recently, of *Circle's Apprentice* (poems), *A Brighter Word Than Bright: Keats at Work*, and a novel, *An Impenetrable Screen of Purest Sky*. He is currently a Monfort Professor at Colorado State University, where he teaches in the MFA Creative Writing Program.

Supriya Bhatnagar is the Director of Publications for the Association of Writers & Writing Programs (AWP) and editor of the *Writer's Chronicle*. She has an MFA in creative nonfiction from George Mason University. Her memoir, *and then there were three ...*, was published in 2010 by Serving House Books. She is a Pushcart nominee for her essay in *Drunken Boat*.

Michelle Boisseau has twice received National Endowment for the Arts poetry fellowships. Her fourth book of poems, *A Sunday in God-Years* (2009), was published by the University of Arkansas Press, which also published her third, *Trembling Air* (2003), a PEN USA finalist. Her poems have appeared in *Poetry, Yale Review, Gettysburg Review, Hudson Review, Kenyon Review*, and *Threepenny Review*.

Bruce Bond is the author of nine published books of poetry, most recently *Choir of the Wells* (Etruscan Press, 2013) and *The Visible* (Louisiana State University Press, 2012). Forthcoming books include *The Other Sky* (Etruscan Press), *For the Lost Cathedral* (Louisiana State University Press), and *Immanent Distance: Poetry and the Metaphysics of the Near at Hand* (University of Michigan Press). At present he is a Regents Professor of English at the University of North Texas and Poetry Editor for *American Literary Review*.

Jericho Brown teaches at Emory University. His poems have appeared or are forthcoming in journals and anthologies including the *New Yorker, New Republic*, and *Best American Poetry*. His first book, *Please*, won the American Book Award, and his second book, *The New Testament*, is forthcoming from Copper Canyon Press.

Lily Brown is the author of the poetry collection *Rust or Go Missing* (Cleveland State University Poetry Center, 2011) and several chapbooks, including *The Haptic Cold* (Ugly Duckling Presse, 2013). She was born and raised in Massachusetts.

Alison Calder is the author of the Coteau Books poetry collections, *Wolf Tree* (2007) and *In the Tiger Park* (2014). Born in London, England, and raised in Saskatoon, she completed Master's and PhD programs at the University of Western Ontario and currently teaches Canadian literature and creative writing at the University of Manitoba.

Jared Carter lives in Indiana. His sixth book, *Darkened Rooms of Summer: New and Selected Poems*, was published in 2014 by the University of Nebraska Press.

Bruce Checefsky received a MFA in Photography from Cranbrook Academy of Art. He also studied at the International Center of Photography in New York City. His works are in the permanent collections of the Museum of Modern Art, Whitney Museum of American Art, and Brooklyn Museum of Art, among others.

Gillian Conoley is the author of seven collections of poetry; her most recent book, *Peace*, will appear with Omnidawn in 2014. Her translation *Thousand Times Broken: Three Books by Henri Michaux* will be out in City Lights Pocket Poets Series in fall 2014.

Matthew Cooperman is the author of *Still: of the Earth as the Ark which Does Not Move* (Counterpath Press, 2011), *DaZE* (Salt Publishing, 2006), and *A Sacrificial Zinc* (Pleiades/Louisiana State University Press, 2001), as well as three chapbooks. An image + text book (w/artist Marius Lehene), *Imago for the Fallen World*, is just out from Jaded Ibis Press. He teaches at Colorado State University in Fort Collins, where he lives with the poet Aby Kaupang and their two children. More at www.matthewcooperman.com.

Anne Devaney taught painting, drawing, and art history at colleges in the American Midwest from 1981 until 2007 when she retired to work full-time as an artist and art historian. Her cut paper images evolved from previous work as a landscape painter. Her art historical research focuses on Fairfield Porter.

Debra Di Blasi is an award-winning multimedia author of six books, including *The Jirí Chronicles* and *Drought*. Her writing appears in leading anthologies of innovative literature, with adaptations to film, radio, theater, and audio CD. As founding publisher of Jaded Ibis Productions, she is a noted lecturer on the intersection of literature, publishing, and technology.

Ien Dobbelaar lives in Leiden. A graduate of the Royal Academy of Arts in the Hague, she has exhibited work in various media (paintings, photography, sculpture, installations ...) widely in the Netherlands, across Europe, and in the U.S. and China.

Jason Dodge was born in Pennsylvania in 1969. His current exhibitions include the 53rd Venice Biennale, Biennale de Lyon, Mercosul Biennial in Porto Alegre, Brazil, and a solo exhibition at the Henry Art Gallery in Seattle.

Born in Austin Texas, **Daniel Dove** received a BFA from the University of Texas and an MFA from Yale University. He has had solo shows at galleries and universities around the United States. Currently, he is a Professor of art at California Polytechnic State University in San Luis Obispo, California.

Christine Drake is a painter and printmaker. She earned a master's degree from New York University in 2002. Her work has been exhibited across the United States and abroad. Her work has been collected into the Museum of Modern Art's Artist's File Archive, the Beijing Natural Culture Center in China, and the Drawing Center in New York City.

Denise Duhamel is the author, most recently, of *Blowout* (University of Pittsburgh Press, 2013), *Ka-Ching!* (2009), *Two and Two* (2005), and *Queen for a Day: Selected and New Poems* (2001). Guest editor for *The Best American Poetry 2013*, she teaches at Florida International University in Miami.

Brian Dupont was born in Tacoma, Washington. He received a BFA from the Kansas City Art Institute and his MFA from Cornell University. He currently lives and works in Brooklyn, New York. His practice focuses on the intersection of process, structure, and text. His work can be seen at briandupont.com.

Lisa Fishman is Associate Professor of English at Columbia College in Chicago and the author of five books of poetry: *Current* (Parlor Press, 2010), *Flower Cart* (Ahsahta, 2011), *The Happiness Experiment* (Ahsahta, 2007), *Dear, Read* (Ahsahta, 2002), and *The Deep Heart's Core Is a Suitcase* (New Issues Press, 1996).

Nina Foxx is a novelist, playwright, and filmmaker. Her work has won various awards and been featured in film festivals around the world. She holds an MFA in Creative Writing and a PhD in Industrial and Organizational Psychology. Her twelfth book, a creative nonfiction anthology, will be published by Simon and Schuster.

Christine Gelineau is the author of *Appetite for the Divine* and *Remorseless Loyalty*, both from Ashland Poetry Press, and co-editor of the anthology *French Connections: A Gathering of Franco-American Poets*. A recipient of the Pushcart Prize, Gelineau teaches at Binghamton University and in the low-residency MFA program at Wilkes University in Northeastern Pennsylvania.

Murat Germen is a professor of photography, art, new media at Sabanci University in Istanbul. Has contributed to over fifty inter/national group/solo exhibitions. He is represented by C.A.M. Gallery (Turkey), ARTITLED! (Netherlands and Belgium), and the Rosier Gallery (USA). His works are in personal collections inter/nationally, including the Istanbul Modern and Proje4L Elgiz Museum collections.

Veronica Golos is the author of *Vocabulary of Silence* (Red Hen Press), winner of the 2011 New Mexico Book Award, poems from which are translated into Arabic by poet Nizar Sartawi; and *A Bell Buried Deep* (Storyline Press), co-winner of the Nicholas Roerich Poetry Prize; to be reissued by Tupelo Press.

Alyson Hagy is the author of seven works of fiction, including the novel *Boleto* and the story collection *Ghosts of Wyoming*. She lives and works in Laramie, Wyoming.

Julie Hanson is the author of *Unbeknownst* (University of Iowa Press, 2011) winner of the Iowa Poetry Prize and finalist for the 2012 Kate Tufts Discovery Award. Her poems have earned awards from the *Cincinnati Review*, *New Ohio Review*, and a fellowship from the National Endowment for the Arts.

Associate Professor **Leah Hardy** currently resides in Laramie, Wyoming, and heads the Metalsmithing Program in the University of Wyoming Department of Art. Hardy's intimately scaled sculptural works have been exhibited nationally and internationally. Traveling, parenthood, and a house full of fuzzy four-legged friends continually inspire Hardy's creative work. Visit leahmhardy.com.

Warren Heiti is the author of *Hydrologos* (Pedlar Press, 2011). He is a teaching fellow at the University of King's College in Halifax, Nova Scotia.

Alisa Henriquez first studied art at Emily Carr College of Art and Design in Vancouver, Canada. She received a BFA from Rhode Island School of Design and an MFA from Indiana University. She currently lives and works as an Associate Professor of Painting at Michigan State University in East Lansing, Michigan.

Adriane Herman has exhibited and lectured widely, and has work in the Whitney Museum of American Art in New York City. Her independent efforts to normalize consumption of fine art dovetail with collaborations such as Slop Art and projects undertaken with Maine College of Art students. She received degrees from Smith College and the University of Wisconsin-Madison.

Originally from Kansas City, Missouri, **Phillip Michael Hook** spent most of his childhood in the small town of Boonville, Missouri. He received his MFA in painting and drawing from the University of Missouri-Columbia and is an Associate Professor of Art in the Department of Art at the University of South Dakota, Vermillion.

Cassandra Hooper is a New York–based artist whose recent work, photolithographs and artists' books, continue her interest in the play/tug between identity and public persona. Her works are exhibited internationally and placed in numerous public collections. She received her BFA from California State University at Long Beach and her MFA from Purchase College, State University of New York, where she holds the position of Doris and Karl Kempner Distinguished Associate Professor.

Born in Seoul, **Leeah Joo** moved to the United States at age ten with her family. Since receiving her MFA in Painting from Yale in 1996, she has been painting and teaching. A Pollock-Krasner and Puffin grant recipient, she lives and works in Connecticut.

Andrew Joron is the author of *Trance Archive: New and Selected Poems* (City Lights, 2010). *The Cry at Zero*, a selection of his prose poems and critical essays, was published by Counterpath Press in 2007. He lives in Berkeley, California, where he theorizes using the theremin.

Kirsten Kaschock is the author of two poetry books: *Unfathoms* (Slope Editions) and *A Beautiful Name for a Girl* (Ahsahta Press). Her novel *Sleight* was published by Coffee House Press. She holds PhDs from the University of Georgia and Temple University. Her manuscript *The Dottery* won the 2013 Donald Hall Prize for poetry from the Association of Writers and Writing Programs.

Scott King, poet, translator, and odonatologist, is the founder and editor of Red Dragonfly Press. He is a lifetime resident of Minnesota and author of two books of poetry and several volumes of field notes about dragonflies.

Caleb Klaces was born in Birmingham, UK, in 1983. He is the author of the poetry collection *Bottled Air* (Eyewear, 2013) and the chapbook *All Safe All Well* (Flarestack, 2011).

Jane Lackey lives and works in Santa Fe, New Mexico. She has had numerous national and international exhibitions, residencies, and grants. Lackey was awarded the US-Japan Creative Artist Exchange Fellowship for 2011. Her academic positions include Artist-in-Residence, Head of Fiber at Cranbrook Academy of Art, and Professor, Kansas City Art Institute. Visit http://www.janelackey.com/.

Jacqueline Jones LaMon is the author of two collections, *Last Seen*, a Felix Pollak Poetry Prize selection, and *Gravity, U.S.A.*, recipient of the Quercus Review Press Poetry Series Book Award; and the novel, *In the Arms of One Who Loves Me*. She lives in New York City and teaches at Adelphi University.

Christopher Leitch is an artist and museum professional from Kansas City. He has attempted his career making a clumsy virtue of ignorance, with varied successes to date. His drawings have been widely exhibited, his art criticism published internationally; he has curated many exhibits and edited numerous publications. His 12' x 17' installation-painting *you are what you hate* was collected in 2009 by the Nerman Museum of Contemporary Art.

Anne Lindberg's work has been exhibited internationally in Norway, Brazil, and Burma, and in the United States in such venues as the Nerman Museum of Contemporary Art, Detroit Institute of Art, Bemis Center for Contemporary Art, Cranbrook Art Museum, Nevada Museum of Art, and Kemper Museum of Contemporary Art. Her work has been recognized with a 2011 Painters and Sculptors Joan Mitchell Foundation Grant, Charlotte Street Foundation Fellowship, American Institute of Architects Allied Arts and Crafts Award, and a Mid-America National Endowment for the Arts Fellowship.

Rupert Loydell is Senior Lecturer in English with Creative Writing at Falmouth University, in Cornwall, England, and the editor of *Stride* magazine. He is the author of several collections of poetry, including *Wildlife* and *Ballads of the Alone*, both published by Shearsman Books. An artist's book-in-a-box, *The Tower of Babel*, was recently published by Like This Press; and *Encouraging Signs*, a book of essays, articles, and interviews was published by Shearsman Books.

Jill Magi works in text, image, and textile. She is the author of *LABOR, SLOT, Threads, Cadastral Map*, and *Torchwood*. A text-image theory and curriculum from a poet's point of view is forthcoming from Rattapallax/Furniture in Motion Press. She is on the faculty of New York University, Abu Dhabi.

Barbara Maloutas' latest book is *The Whole Marie*. Her last chapbook is *of which anything consists*. Previous books and chapbooks include *Her Not Blessed, In a Combination of Practices, Coffee Hazilly*, and *Practices*. A limited fine press edition on water from *of which anything consists* was recently published. Her work has appeared in *Aufgabe, FreeVerse, Tarpaulin Sky, bird dog, dusie, elimae, Puerto del Sol, Octopus, Or*, and other venues. Maloutas is also a book artist.

Katherine Tzu-Lan Mann received her BA from Brown University and MFA from the Maryland Institute College of Art in Baltimore. She is the recipient of a Fulbright grant and has exhibited her work across the United States, Canada, France, the United Kingdom, Switzerland, the United Arab Emirates, Cameroon, and Taiwan.

China Marks uses an industrial sewing machine and a computerized embroidery machine to make drawings, broadsides, and books from fabric and thread. Her work is

shown in galleries and museums in the United States and Europe. She has received many grants and fellowships, including New York Foundation of the Arts fellowships in 2005 and 2011 and a Pollock-Krasner Foundation grant in 2013. Visit www .chinamarks.net.

Valerie Martínez is a poet, translator, educator, librettist, and collaborative artist. Her sixth book of poetry, *Each and Her* (winner of the 2012 Arizona Book Award), was nominated for the Pulitzer Prize, the National Book Critics Circle Award, the PEN Open Book Award, the William Carlos William Award, and the Ron Ridenhour Prize.

Kristi Maxwell's books include *Re-* (Ahsahta Press, 2011), *That Our Eyes Be Rigged* (Saturnalia Books, 2014), and *Plan/K* (Gold Wake Press, 2014). She is a lecturer in the English Department at the University of Tennessee and a co-founder of Know-How, a Knoxville organization that focuses on social justice and youth empowerment through the arts.

Ann McCutchan is the author of four books, and a varied body of work in creative nonfiction, journalism, opera libretti, and other musical forms. She teaches creative writing at the University of North Texas, where she is editor of the *American Literary Review*.

Philip Metres is the author of numerous books, recently *A Concordance of Leaves* (2013) and *abu ghraib arias* (2011), which won the Arab American Book Award. He is the recipient of a 2013 National Endowment for the Arts Award and he recently won the Beatrice Hawley Award for *Sand Opera* (forthcoming).

Thomas Lyon Mills is represented by the Luise Ross Gallery in New York City and is Professor of Drawing at the Rhode Island School of Design, receiving RISD's John R. Frazier Award for Excellence in Teaching (1996). For his exhibition record, lectures, and workshops visit www.thomaslyonmills.com.

Carol Moldaw's most recent book is *So Late, So Soon: New and Selected Poems* (Etruscan Press, 2010). She is the author of four other books of poetry, including *The Lightning Field* (2003), which won the 2002 FIELD Poetry Prize, and a novel, *The Widening* (Etruscan Press, 2008). Visit www.carolmoldaw.com.

Susan Moldenhauer has created poetic, personal images in outdoor settings since 1981; the American West has dominated her work since 1988. Her MFA in photography is from Pennsylvania State University. She has had numerous exhibitions in North America and is represented in public and private collections. She lives in Laramie, Wyoming.

Laura Mullen is the McElveen Professor at Louisiana State University. She is the author of seven books: *Enduring Freedom: A Little Book of Mechanical Brides*, *The Surface*, *After I Was Dead*, *Subject*, *Dark Archive*, *The Tales of Horror*, and *The Murmur*. Her work has been widely anthologized and is included in *Postmodern American Poetry*, *American Hybrid* (Norton) and *I'll Drown My Book: Conceptual Writing by Women* (Les Figues).

Jena Osman's recent books of poetry include *Corporate Relations* (Burning Deck, 2014), *Public Figures* (Wesleyan University Press, 2012), and *The Network* (Fence Books, 2010). She co-edits the ChainLinks book series with Juliana Spahr and teaches in the MFA Creative Writing Program at Temple University in Philadelphia.

Sreshta Rit Premnath (born in 1979 in Bangalore) is an interdisciplinary artist and educator based in New York. His work has been presented in solo exhibitions including Plot, Gallery SKE, Bangalore, 2013; Folding Rulers, Contemporary Art Museum, St Louis; The Last Image, Tony Wight Gallery, Chicago, 2012; Storeys End, Galerie Nordenhake, Berlin, 2011; Zero Knot, Art Statements, Art|41|Basel, 2010.

Lia Purpura is the author of seven collections of essays, poetry, and translations. *On Looking* (essays, Sarabande Books) was a finalist for the National Book Critics Circle Award. She is a recent Guggenheim Foundation Fellow. Her work can be read in the *New Yorker*, *Nation*, *Orion*, and elsewhere. She lives in Baltimore, Maryland, and is Writer in Residence at the University of Maryland, Baltimore County.

Mary Quade is author of the poetry collection *Guide to Native Beasts* (Cleveland State University Poetry Center). She is the recipient of an Oregon Literary Fellowship and two Ohio Arts Council Individual Excellence Awards. She teaches creative writing at Hiram College in Ohio.

Ecological artist **Aviva Rahmani** works with teams of scientists, planners, environmentalists, and artists to restore degraded environments. As an Affiliate at the Institute of Alpine and Arctic Research, University of Colorado at Boulder, she has worked on global warming with the Director, Dr James White, since 2007 and is a researcher at the University of Plymouth, UK. Rahmani's work is internationally exhibited and published.

Bin Ramke's first book was published by Yale University Press; his eleventh, *Aerial*, by Omnidawn. At the University of Denver he holds the Phipps Chair and is an Evans Professor; for seventeen years he edited the *Denver Quarterly*. He also teaches at the School of the Art Institute of Chicago.

Paisley Rekdal is the author of two books of nonfiction and four books of poetry, the most recent of which is *Animal Eye*.

Doug Russell is a visual artist who lives and works in Laramie, Wyoming. He earned an MFA in Printmaking and Drawing from the University of Iowa, and a BFA from Columbia College. He currently holds the position of Associate Professor at the University of Wyoming, where he is Coordinator of the Drawing Program.

Jim Sajovic's works are held in public and private collections in the United States, Europe, and Asia. He has exhibited at galleries and museums, nationally and internationally, including New York, Chicago, Atlanta, Los Angeles, Paris, and Venice. He was one of six artists featured in the recent exhibition, *Be Inspired*, at the Kemper Museum Crossroads in Kansas City.

Zach Savich is the author of four books of poetry, including *Century Swept Brutal* (Black Ocean Press, 2014) and *The Firestorm* (Cleveland State University Poetry Center, 2011). He teaches at the University of the Arts in Philadelphia.

In addition to conducting experiments in paint, **Vera Scekic** curates shows and writes art reviews and commentary. She has exhibited her paintings, drawings, and installations at a variety of spaces in Chicago and other cities. She lives in Racine, Wisconsin, with her husband and twin daughters.

Shelby Shadwell actively exhibits across the United States and was recently featured in the International Drawing Annual 5 and 6 publications through the Manifest Creative Research Gallery and Drawing Center in Cincinnati, Ohio, where he also had a solo show in February 2013. Shelby is currently an Assistant Professor in the Art Department at the University of Wyoming.

Anis Shivani is the author of *My Tranquil War and Other Poems*, *The Fifth Lash and Other Stories*, *Against the Workshop*, *Anatolia and Other Stories*, and the forthcoming novel *Karachi Raj*. His books that have recently been finished or in progress include *Soraya: Sonnets*, *Literature at the Global Crossroads*, *Plastic Realism*, and *Abruzzi*, 1936.

Evie Shockley has published two poetry books — *the new black* and *a half-red sea* — and the critical study *Renegade Poetics: Black Aesthetics and Formal Innovation in African American Poetry*. She serves as creative editor in the *Feminist Studies* editorial collective and is Associate Professor of English at Rutgers University–New Brunswick.

Sandra Simonds is the author of *Warsaw Bikini* (Bloof Books, 2009), *Mother Was a Tragic Girl* (Cleveland State University Press, 2012), *The Sonnets* (Bloof Books, 2014), and *The Glass Box* (Saturnalia Books, 2015).

Sue Sinclair is the author of four books of poetry, most recently *Breaker* from Brick Books. Her work has been nominated for numerous national and regional awards. She has recently completed a PhD in philosophy at the University of Toronto, where she is writing about beauty.

Johanna Skibsrud is the author of the Scotiabank Giller Prize winning novel *The Sentimentalists* as well as a book of short fiction, *This Will Be Difficult to Explain, and Other Stories*, and two collections of poetry: *Late Nights with Wild Cowboys* and *I Do Not Think That I Could Love a Human Being*.

Juliana Spahr edits with Jena Osman the book series Chain Links, with nineteen other poets she edits the collectively funded Subpress, and with Joshua Clover and Jasper Bernes she will begin editing Commune Editions. With David Buuck she wrote *Army of Lovers*, a book about two friends who are writers in a time of war and ecological collapse (forthcoming from City Lights).

Alex Stein works in the Norlin library at the University of Colorado in Boulder. He was born in Seattle, Washington, and raised in Vancouver, British Columbia.

Catherine Taylor is a writer and editor who works on a wide range of nonfiction forms — from documentary and literary journalism to lyric essays, hybrid-genre writing, critical theory, and poetics. She is the author of *Apart*, a hybrid-genre book of memoir and political history about South Africa (Ugly Duckling Presse, 2012), and of *Giving Birth: A Journey Into the World of Mothers and Midwives* (Penguin Putnam), winner of the Lamaze International Birth Advocate Award.

A former NEA Fellow, **Brian Teare** is the author of four books — *The Room Where I Was Born*, *Sight Map*, the Lambda Award–winning *Pleasure*, and *Companion Grasses*. An Assistant Professor at Temple University, he lives in Philadelphia, where he makes books by hand for his micropress, Albion Books.

Gerry Trilling has been intrigued by the organizational rhythms of patterns since she first crocheted a hanger at camp. She has traveled extensively, engaging in independent studies in Bangkok, Bali, South Korea, New York, and London. Her work has been shown in galleries and museums throughout the Midwest.

Anna Von Mertens is the recipient of a 2010 United States Artists Fellowship and a 2007 Louis Comfort Tiffany Biennial Award. Von Mertens work has been exhibited internationally and is in the permanent collections of the Museum of Fine Arts, Boston; the Berkeley Art Museum; the Smithsonian American Art Museum's Renwick Gallery; and the Rhode Island School of Design Museum, among other institutions.

Kathleen Wakefield is an author and lyricist who began her songwriting career at Motown Records. Her songs have been recorded by such artists as Quincy Jones, James Ingram, Frank Sinatra, Barbra Streisand, and Michael Jackson. Her novella *Snaketown* won the 2007 Ruthanne Wiley Memorial Novella Contest. She lives in Los Angeles and the Pacific northwest, where she has just finished a novel with six illustrations.

Sarah Walko is a multimedia artist and writer, currently the executive director of Triangle Arts Association, a nonprofit arts organization in Brooklyn, New York. Her recent exhibitions include *Preternatural* at the Museum of Nature in Ottawa, *Codex Dynamic* in New York, *Wonder Cabinet* in New York, and *A Necessary Shift* at the Elizabeth Foundation in New York.

Afaa Michael Weaver is a native of Baltimore, Maryland. A National Merit Scholar, he entered the University of Maryland in 1968 at 16 and left in 1970 to spend 15 years as a factory worker in Baltimore, a period wherein he wrote and published as a poet, journalist, and fiction writer. In 1985 he received a National Endowment for the Arts Fellowship and left factory life to study at Brown University. Also a playwright, Weaver's twelfth collection of poetry is *The Government of Nature* (University of Pittsburgh Press, 2013).

Jonathan Weinert is the author of *In the Mode of Disappearance* (Nightboat, 2008), winner of the Nightboat Poetry Prize, and a chapbook, *Thirteen Small Apostrophes* (Back Pages, 2013). He is co-editor of *Until Everything Is Continuous Again: American Poets on the Recent Work of W.S. Merwin* (WordFarm, 2012).

The author of three books of poetry – *monkeypuzzle*, *forage*, and *sybil unrest* (with Larissa Lai) – **Rita Wong** lives on the unceded Coast Salish territories also known as Vancouver. Her work explores the relations between contemporary poetics, social justice, ecology, decolonization, and water.

Jon Woodward was born in Wichita, Kansas, and has lived in Colorado and Massachusetts. His latest book is *Uncanny Valley* (Cleveland State University Poetry Center, 2012). He lives in Quincy, Massachusetts, with his wife, poet and pianist Oni Buchanan, and he works at the Harvard Museum of Comparative Zoology.

Laurie Saurborn Young is the author of *Carnavoria*, a book of poems, and a chapbook, *Patriot*. Her second book, *Industry of Brief Distraction*, is forthcoming from Saturnalia Books. She holds an MFA in Poetry from Warren Wilson College in North Carolina. A portfolio of her photography work is online at lauriesaurborn.carbonmade.com.